Taking Aim

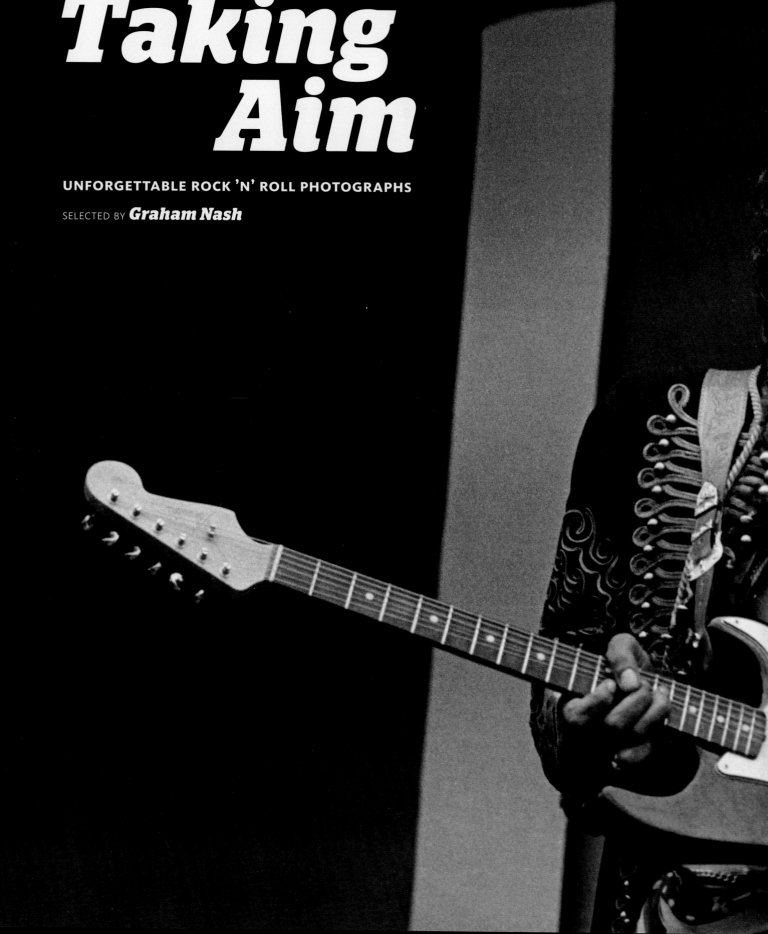

Taking Aim

UNFORGETTABLE ROCK 'N' ROLL PHOTOGRAPHS

SELECTED BY *Graham Nash*

WITH TEXTS BY
Graham Nash AND *Jasen Emmons*

CHRONICLE BOOKS
SAN FRANCISCO

Library of Congress Cataloging-in-Publication Data available.

ISBN: 978-0-8118-7101-3

Manufactured in China.

Design by Brooke Johnson.

Pages 157–159 constitute a continuation of the copyright page.

This book serves as the catalog of the exhibition *Taking Aim*,
organized by Experience Music Project|Science Fiction
Museum and Hall of Fame.

EMP|SFM Experience **Music** Project | **Science Fiction Museum** and Hall of Fame

10 9 8 7 6 5 4 3 2 1

Chronicle Books LLC
680 Second Street
San Francisco, CA 94107
www.chroniclebooks.com

previous spread
Jim Marshall Jimi Hendrix at sound check for the
Monterey Pop Festival, Monterey, California,
June 18, 1967

Rock 'n' roll is mainly an attitude. An attitude about life itself, pitted against the status quo, and against the hypocritical qualities of some of the people running our lives. An attitude that screams at you, "Yes, love is better than hate. Yes, peace is better than war." And it screams at you that, yes, indeed, the emperor really has no clothes. Many musicians have this attitude, and whether you're a country singer, a pop, rock, blues, or gospel singer, it makes little difference to the unceasing eye of the camera.

—GRAHAM NASH

Preface

JASEN EMMONS
CURATORIAL DIRECTOR, EXPERIENCE MUSIC PROJECT

Through my work at Experience Music Project (EMP) curating exhibitions like *Bob Dylan's American Journey, 1956–1966,* conducting interviews, and giving tours at the museum, I've had the good fortune to meet a number of musicians whose work inspires me. My personal perfecta was giving tours of the Bob Dylan exhibition to Elvis Costello and John Prine on successive weeks and hearing their stories of the first time they met him. No musician, as far as I can tell, forgets his first encounter with Dylan, and Graham Nash is no exception, as this book will reveal.

Until this project, I'd never approached an artist about being a guest curator, but as the curatorial team at EMP considered organizing an exhibition about rock 'n' roll photography, Graham Nash seemed the ideal choice. He is a world-class musician who's written unforgettable songs such as "Marrakesh Express," "Our House," and "Teach Your Children" (inspired by the Diane Arbus photograph *Child with toy hand grenade, Central Park*). A different audience knows him as a respected photographer, photography collector (he has lived with the work of Ansel Adams, Julia Margaret Cameron, and Edward Weston, among many others), and pioneer in digital image printing with his internationally renowned studio, Nash Editions, cofounded with R. Mac Holbert.

Rather than simply creating a survey of rock 'n' roll photography, I imagined Nash drawing on his keen eye and rich music history to put together a unique exhibition of rock 'n' roll photographs that would include his insights as a musician and photographer. Still, there were a number of unknowns: would Graham Nash be willing to take on a project that required a lot of time and energy? If he did, what would it be like for me, as a longtime fan, to work with a legendary musician? Would he prove to be a diva? An artiste who believed deadlines stifled his creativity? What if he insisted on creating a retrospective exclusive to his Laurel Canyon musician friends? Could I say, "Wonderful idea, Graham (Mr. Nash?), but no," without offending him?

Fortunately, my concerns were unfounded. He loved the idea of serving as guest curator and threw himself wholeheartedly into the project. During the 2008 Crosby, Stills & Nash tour, Graham looked at hundreds of photographs and e-mailed at all hours about particular images he loved. Later, he generously made his house available for editing sessions and encouraged feedback on his selections. Throughout the whole process, Graham's passion for music and photography was infectious, his focus and dedication impressive. This selection of photographs is a testament to that.

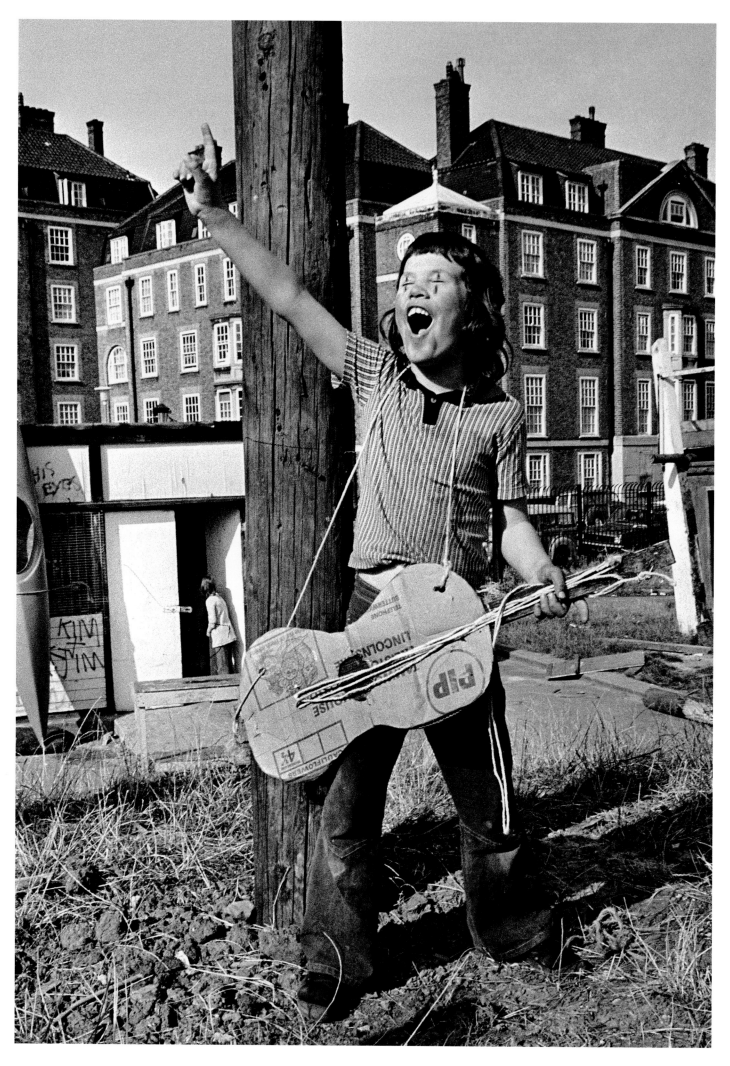

Mick Rock Dude '72, Camden Town, London, England, summer 1972

Introduction GRAHAM NASH

I've been making images longer than I've been making music. While many people identify me as a musician, I've run a parallel life as a photographer and printer.

I am often asked how it is that a musician can make photographs. My explanation is, I sense the very same energy in photography that I find in music. When I look at Ansel Adams's print *Moonrise Over Hernandez* I can feel the basses and cellos in the shadows—I can hear the violins in the clouds. It's all the same energy. Some may not know that Adams was on track to be a concert pianist until he made the choice to focus on photography. Throughout his life he continued to make music in his home, and in his prints. To me, creation is just a question of tapping into this stream of energy that surrounds us daily.

Something fabulous happened to me when I was ten years old. My father showed me a magic trick that astounded my young senses. Placing a blank sheet of paper into a nearly colorless liquid in a tray, he asked me to wait and watch. Wait and watch what? I saw nothing. "Keep watching, son," he said, and as he did, the image of an elephant came floating into view—from nowhere. I recognized the animal from a recent trip to the local zoo. I had watched my father capture that image, which I was now seeing in the tray in a makeshift darkroom he had made in my bedroom. It was a transformative moment. This somewhat crude yet exciting photograph was, of course, black

and white. I think this experience is why I much prefer making images, and am drawn to photographs, in black and white—after all, I already see in color. I have never forgotten those private moments with my father and the way he changed my life.

When Jasen Emmons asked me to curate this exhibition for Experience Music Project, I felt that we were on the very same page about trying to create an enjoyable, visual journey through some bizarre, straight, yet often disturbing, moments in the making of rock 'n' roll music. I jumped at the chance to show that energy from a photographic point of view, to show images that convey what is so difficult to put into words: how the spirit of rock 'n' roll is mainly an attitude, an attitude of "get out of my way, I have something to say here." That perspective permeated John Lee Hooker and the Freedom Singers, and continues to resonate with Woody Guthrie; Pete Seeger; Peter, Paul, and Mary; Bob Dylan; Bruce Springsteen; and a long line of musicians trying to make the world a better place. It spoke to Bill Haley & His Comets, as well as to Bob Marley and Elton John, and every other musician found in these pages as well as the countless others making music around the world.

The final selection here had to resonate with me personally, so it helped that I have collected wonderful images for many years. Initially I whetted my appetite for photography through books, and then began to acquire original prints. Edward Curtis's photographs from his North American Indians project particularly impressed me. I was fascinated by the window these pictures opened into an entirely different time and culture, and yet everything looked so fresh and realistic, defying the passage of time. For the same reason, I have been haunted by Diane Arbus's *Child with toy hand grenade, Central Park* for many years. It was the first photograph I ever bought.

My love for images that have the power to affect me keeps me looking, making my own photographs, and viewing the work of others. While some of the photographs chosen for this project feel timeless, others embody a breathless, fluxing moment for me. A photograph can magically show the movements in the process of that moment or series of moments, becoming a picture that the camera finally records.

I can relate this to music in a certain way—when I finish a song and it's recorded, it's as if I've landed and the movement's over. You see, it's not the capture of the song and the realization of the product that sets me pulsing, it's the pursuit—and the moment at which I decide that it's finished. The search for the elements that combine to make the moment persist in time is a joyful journey.

With a photograph, the viewer is half the strength of a good picture. The onlooker brings to a picture his or her whole life experience, and this fuses with the photograph and makes it come alive. Photographs, in this sense, are potentials waiting to be

activated by the viewer. The same can be said about listening to live music. Everything you've ever experienced in the past comes with you to the concert and makes you appreciate the moments in a more intimate way.

While it must be different for everyone, for me, the move toward taking a picture comes both as a conscious and unconscious act. It is triggered by pure emotion, but carried through by conscious direction: being guided first by one's intuition and then using one's intelligence and creativity to support the idea the intuition proposes. I must admit that it is a little strange looking at images of musicians, many of whom I know personally. In the process of selecting photographs I realized that I had to try to separate my visual approach from my personal feelings about the subjects. These photographs are full of life and feelings—needless to say, they bring a smile to my face and an understanding of just how lucky I am to be a musician and a photographer.

Even though I'm considered well known within certain circles, I'm a huge fan of the photographers represented here. Some are friends, some are acquaintances, and I respect them all deeply. I'm pleased to have been able to share this experience with you. Through the images and the music, the journey continues

Portraits

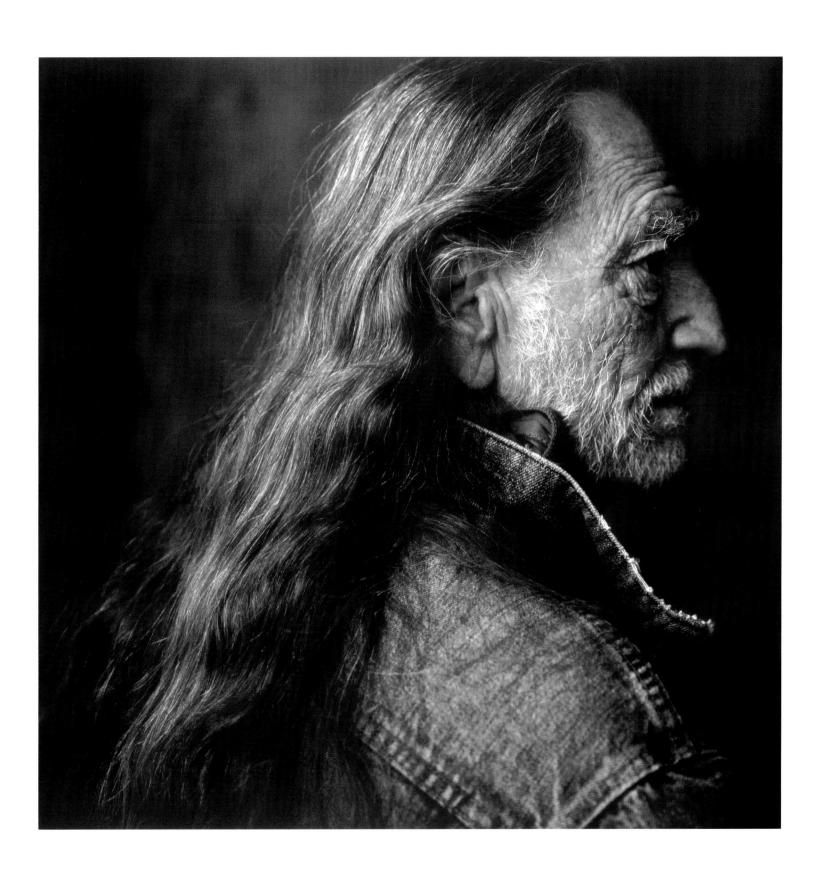

Annie Leibovitz Willie Nelson, Luck Ranch, Spicewood, Texas, 2001

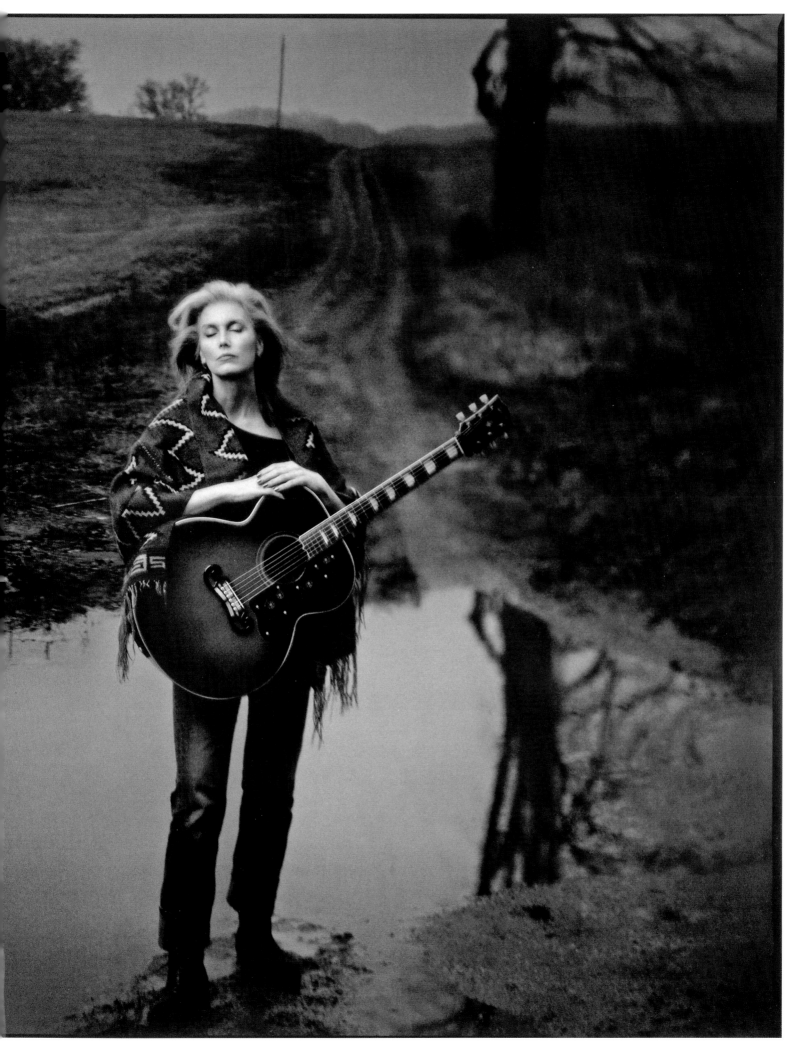

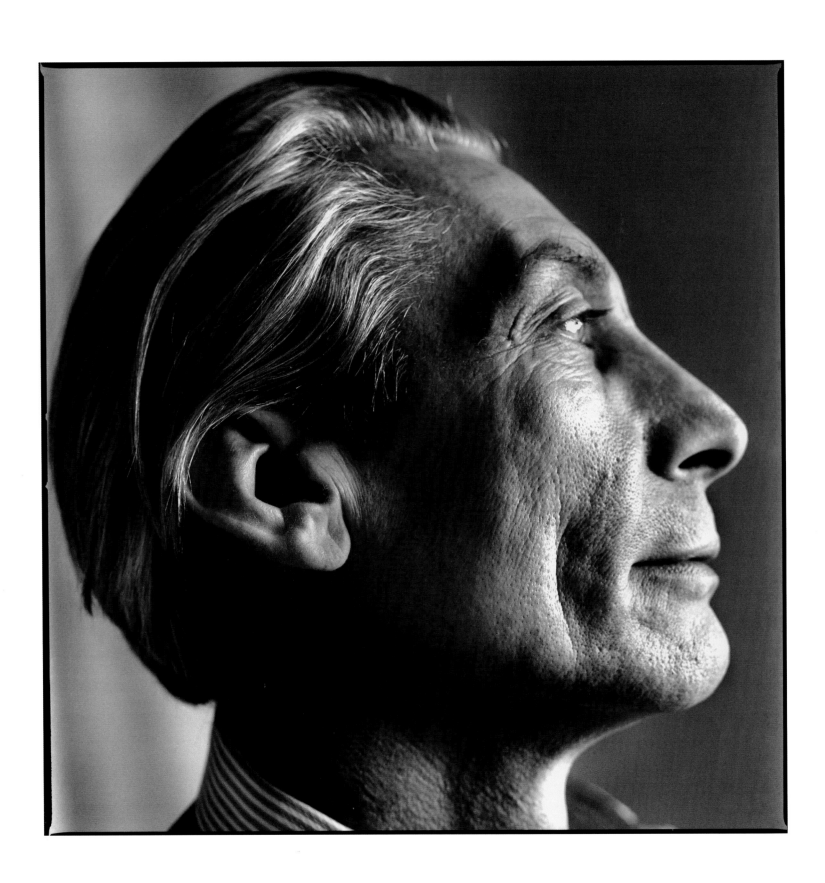

Jill Furmanovsky Charlie Watts at the Halcyon Hotel, Holland Park, London, England, March 1991

What a portrait. He looks like a Rodin statute. I'd like to carve him in marble. —GN

In 1969 my girlfriend at the time, Joni Mitchell, and I went to Nashville, Tennessee. She was appearing on The Johnny Cash Show, *a wonderful moment for Joan; she's such a brilliant artist. I had my camera, and shot this silhouette of Johnny Cash standing there, just reflecting on his life, I'm sure. But this really, to me, is the man in black.* –GN

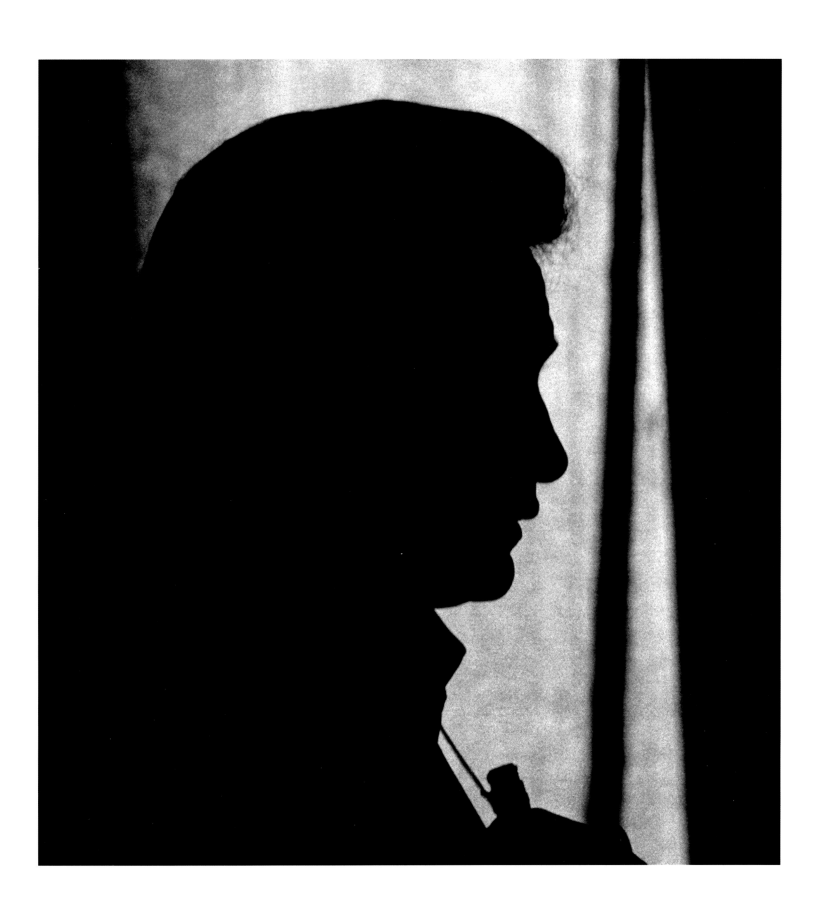

Graham Nash Johnny Cash offstage during *The Johnny Cash Show*, Nashville, Tennessee, June 1969

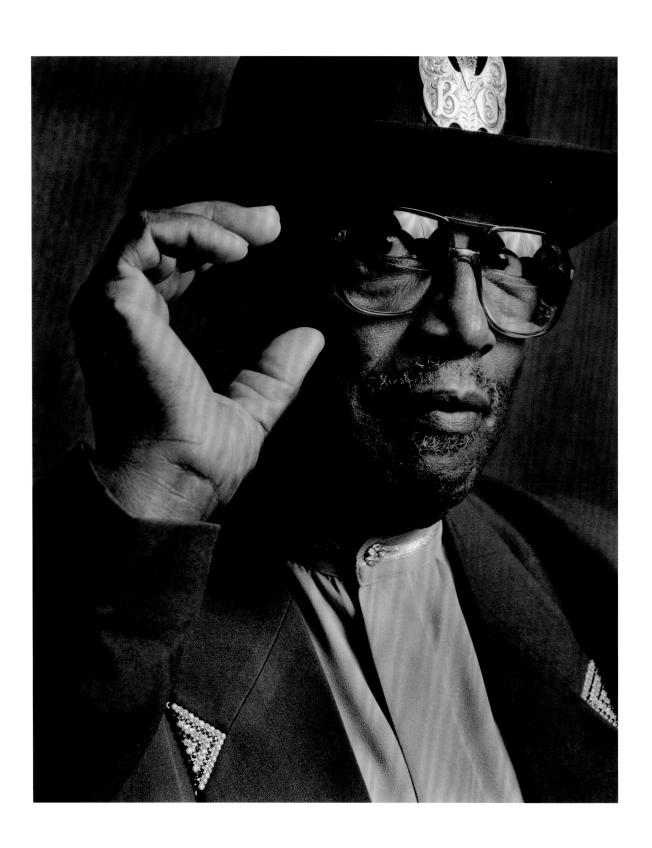

Jeff Dunas Bo Diddley, Los Angeles, California, September 18, 1996

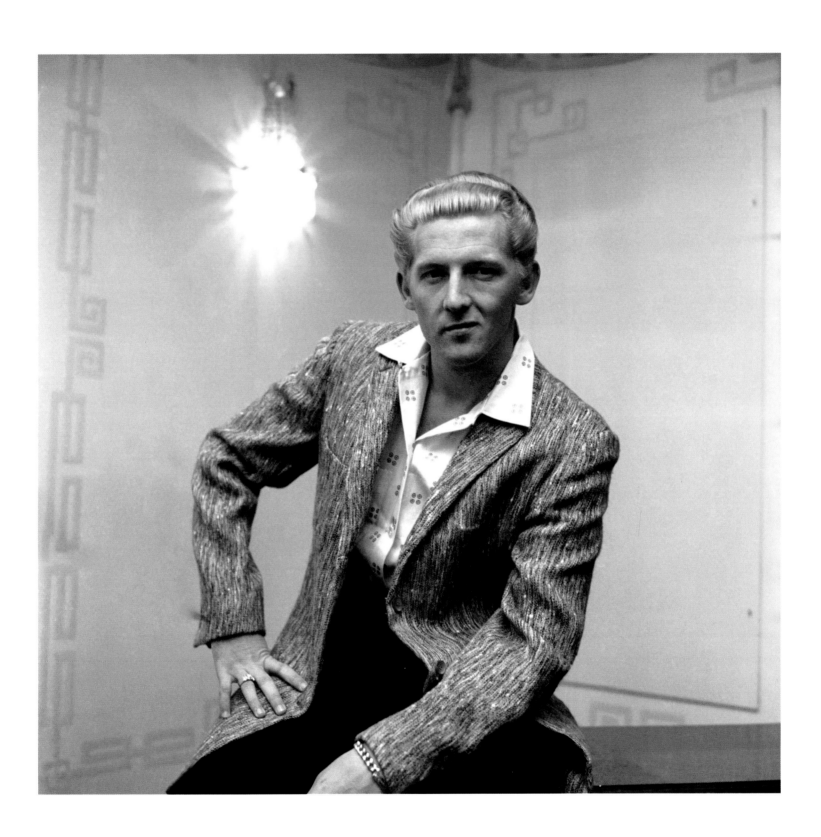

Dezo Hoffman was a very famous English photographer, certainly
during the early sixties when all of those English bands were being
formed. He took pictures of The Beatles, and took many shots of my
band, The Hollies. He did this portrait of Jerry Lee Lewis in 1958.
At that time Lewis was not popular with the English audience
because they'd just discovered that he had married his thirteen-
year-old cousin. –GN

Dezo Hoffman Jerry Lee Lewis, London, England, 1958

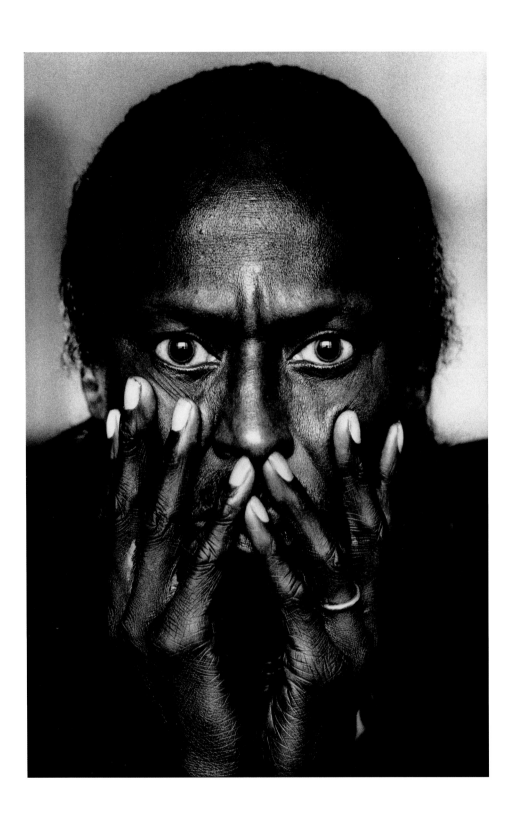

Anton Corbijn Miles Davis, Montreal, Canada, 1985

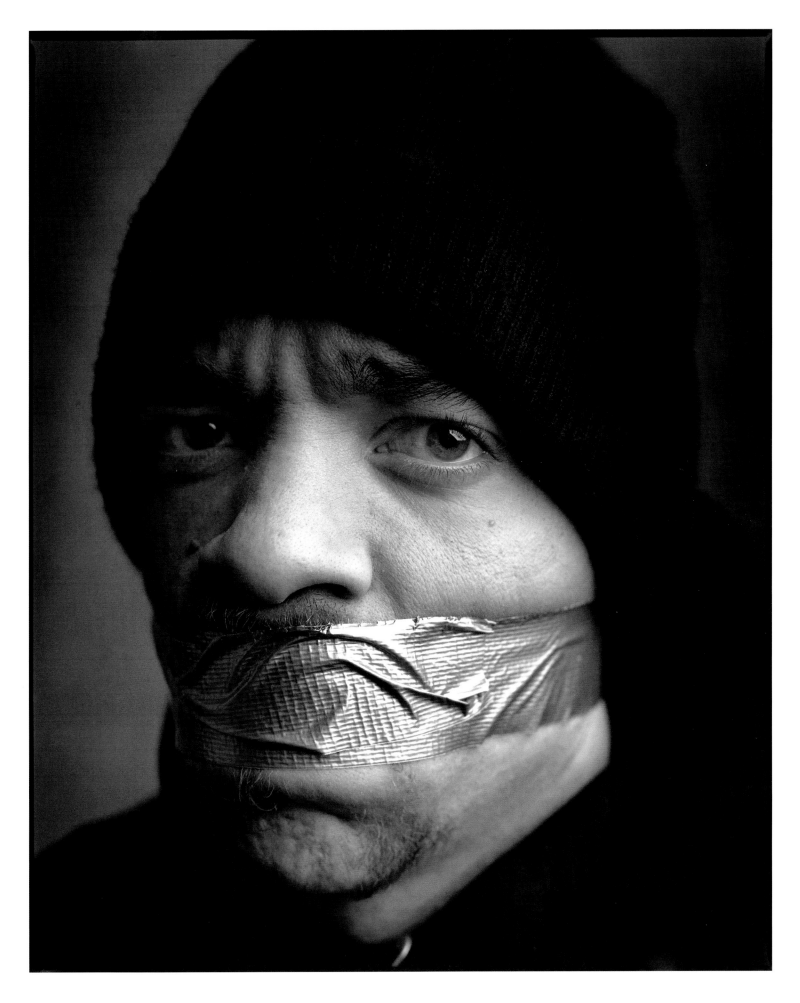

This image really reminds me that we can't shut up.
We must speak our minds. The world is too important;
humanity is too important for us to lie down. –GN

Mark Seliger Ice-T, New York, New York, 1993
This was taken during the controversy over the song
"Cop Killer" by Ice-T and his band, Body Count.

23

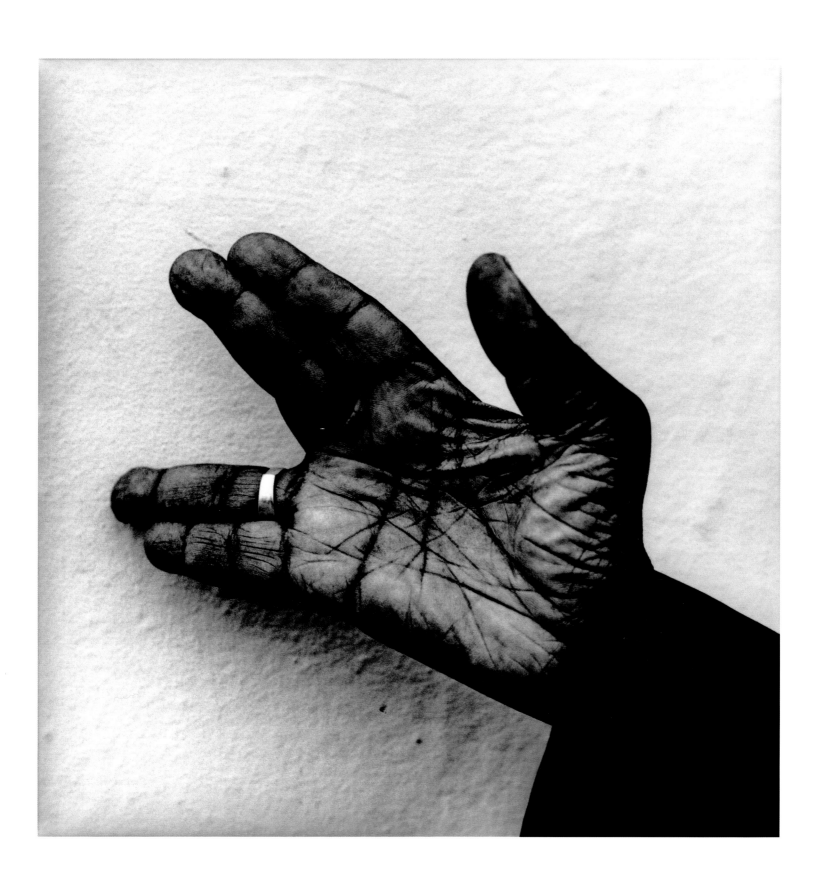

Anton Corbijn John Lee Hooker's hand, Los Angeles, California, 1994

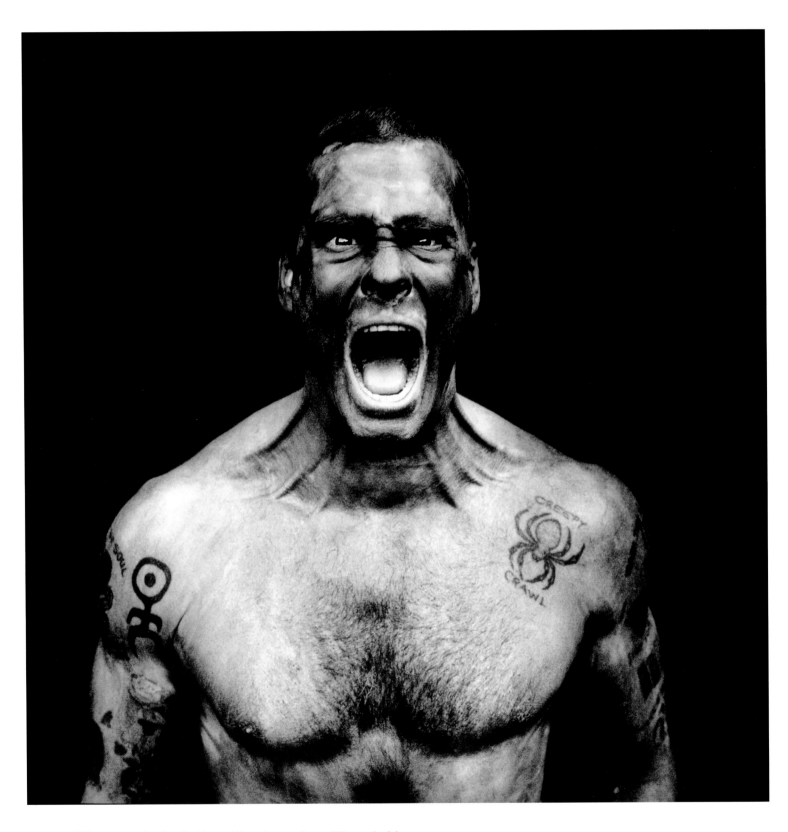

What an attitude. Got to get it out somehow. We probably save ourselves millions in psychiatry bills because we talk to ourselves. Or in Henry's case, scream to ourselves. –GN

Anton Corbijn Henry Rollins, Lancaster, California, 1994

Anton Corbijn Jim Kerr of Simple Minds, Los Angeles, California, 1985

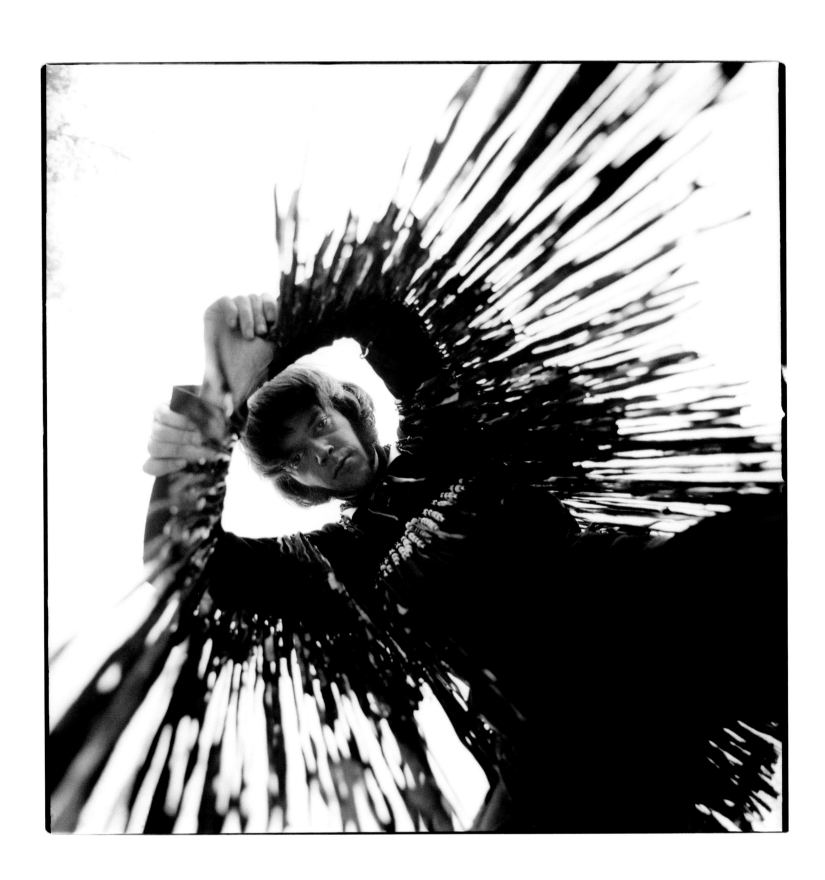

Jini Dellaccio Neil Young, Laurel Canyon, Los Angeles, California, August 1967

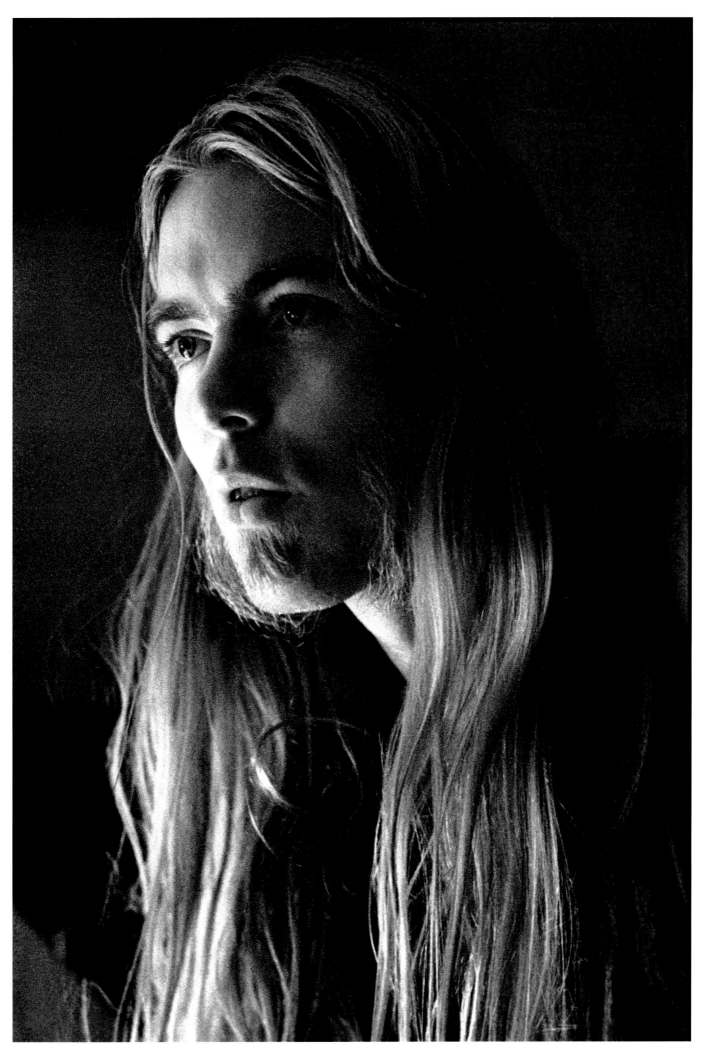

Neal Preston Gregg Allman, Phoenix, Arizona, 1973

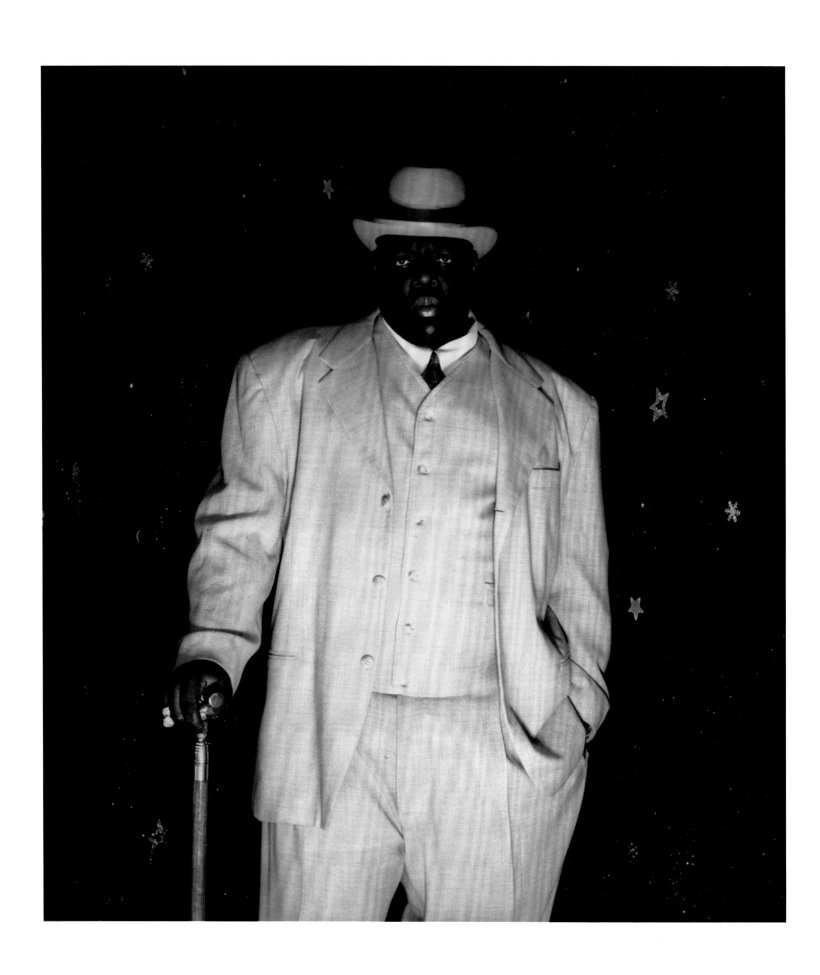

Barron Claiborne Notorious B.I.G., New York, New York, May 2003

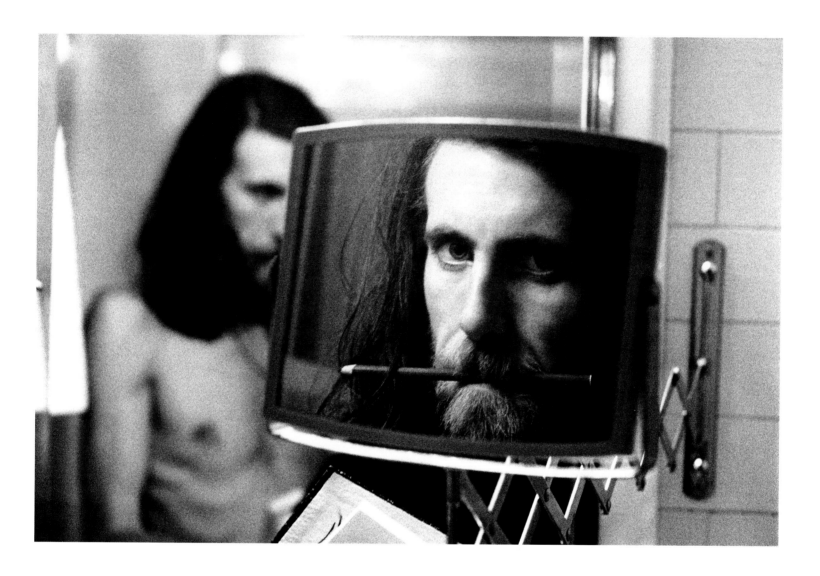

I felt a little uncomfortable including my own images in this
selection, but other people involved with the project forced me
to do it, I'm afraid. It's a portrait I took of myself with the help
of my girlfriend at that time, Calli Cerami, at the Plaza Hotel in
New York City in 1974. It was the waning days of a grueling tour
that Crosby, Stills, Nash & Young took of stadiums around the
country, and we were soon on our way to Wembley Stadium
in England. –GN

Graham Nash *Self-Portrait at the Plaza Hotel*, New York, New York, September 1974

Lynn Goldsmith The Beatles, Miami Beach, Florida, February 13, 1964
This was taken shortly before The Beatles performed on *The Ed Sullivan Show* on February 16, 1964

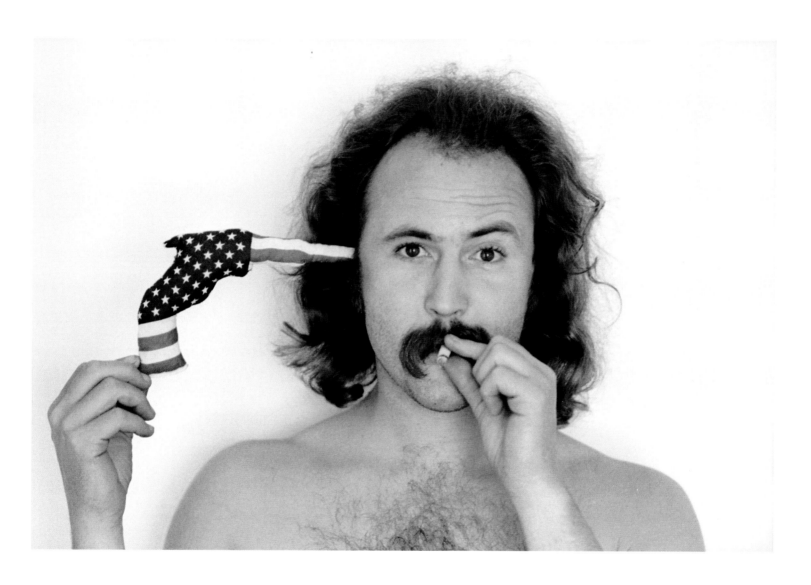

In July of 1970, Crosby, Stills & Nash were in Minneapolis, and
we were staying at the Radisson Hotel. Crosby was in his room.
I walked in and told him, "Hey, David, a fan threw this up on the
stage last night at the concert. You want it?" It was a cloth American
flag made into the shape of a gun, which he immediately put to
his head. You notice that he did not take the joint out of his mouth.
Of course, Henry Diltz was there. –GN

Henry Diltz David Crosby at the Radisson Hotel, Minneapolis, Minnesota, 1970

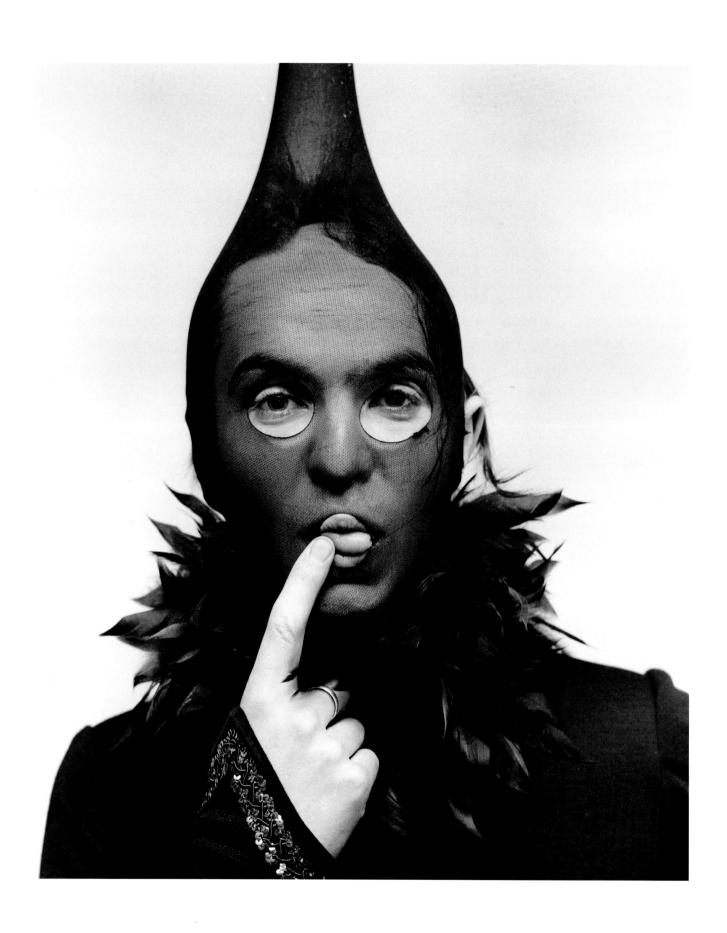

Mick Rock Peter Gabriel at Mick Rock's apartment, King's Cross, London, England, November 1973

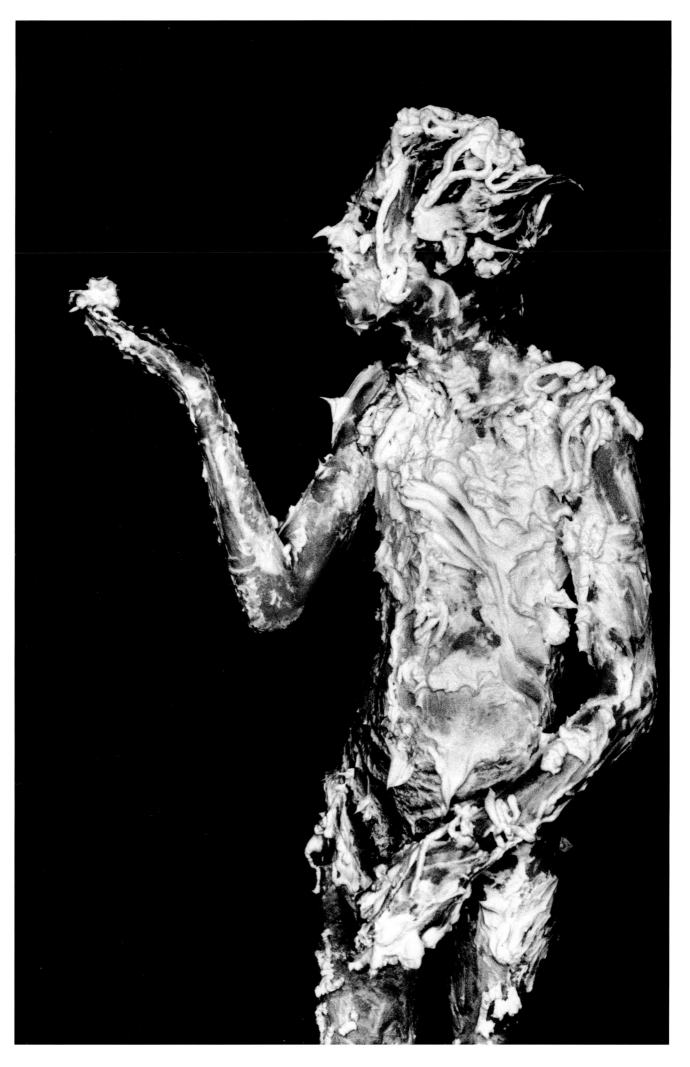

Anton Corbijn Frank Tovey, a.k.a. Fad Gadget, Liverpool, England, 1983

A lot of people say that rock 'n' roll musicians are just children who never really grew up.

Well, look at this shot of Mick Jagger taken in his satin trunks and standing in his sandbox. –GN

Francesco Scavullo Mick Jagger, New York, New York, 1973

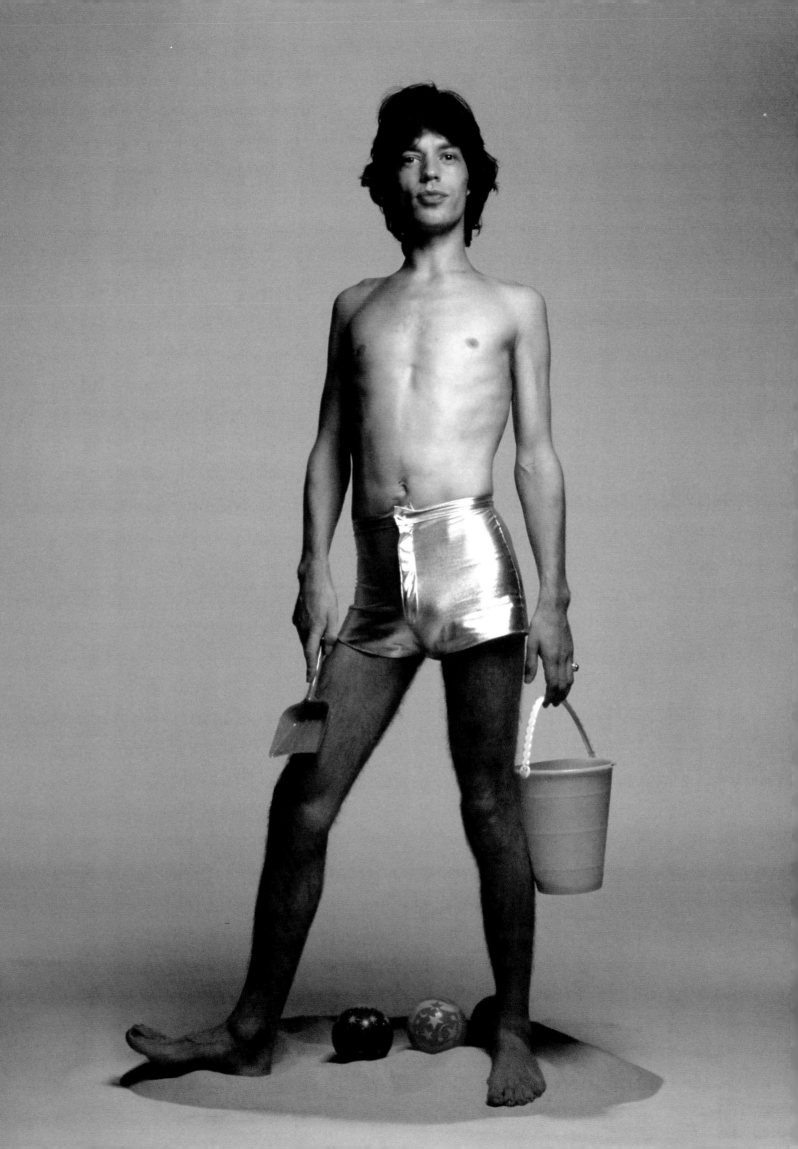

Lynn Goldsmith Marianne Faithful showering, Nassau, Bahamas, 1982

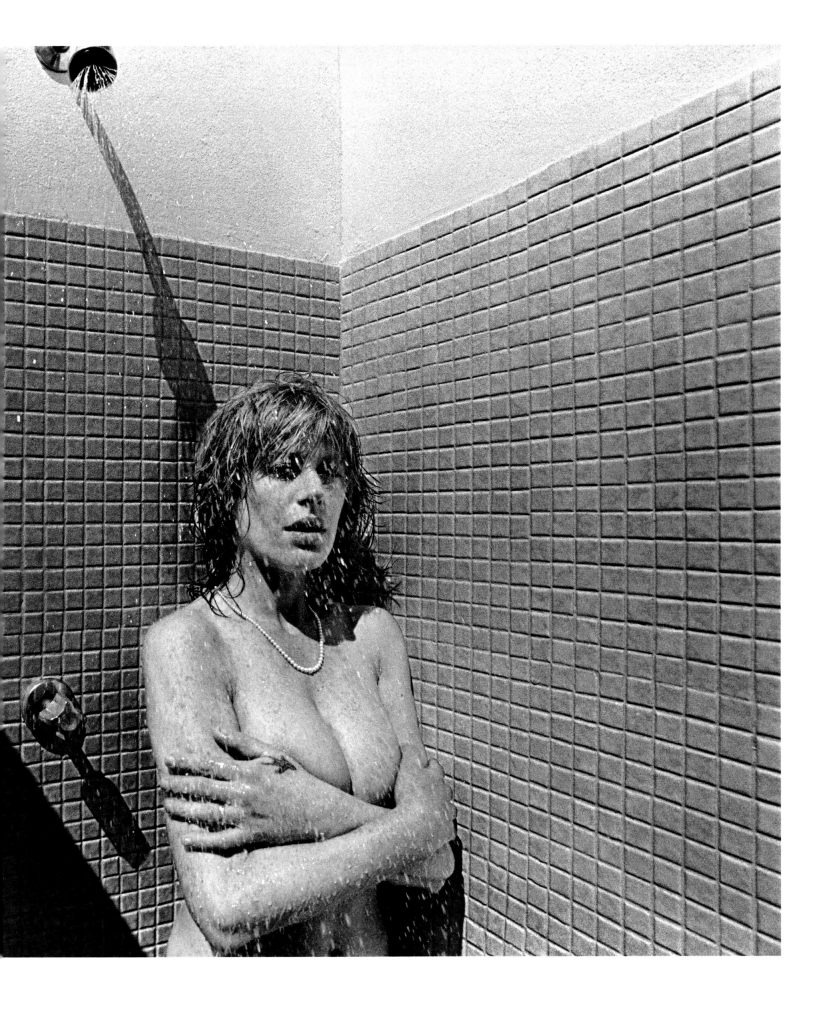

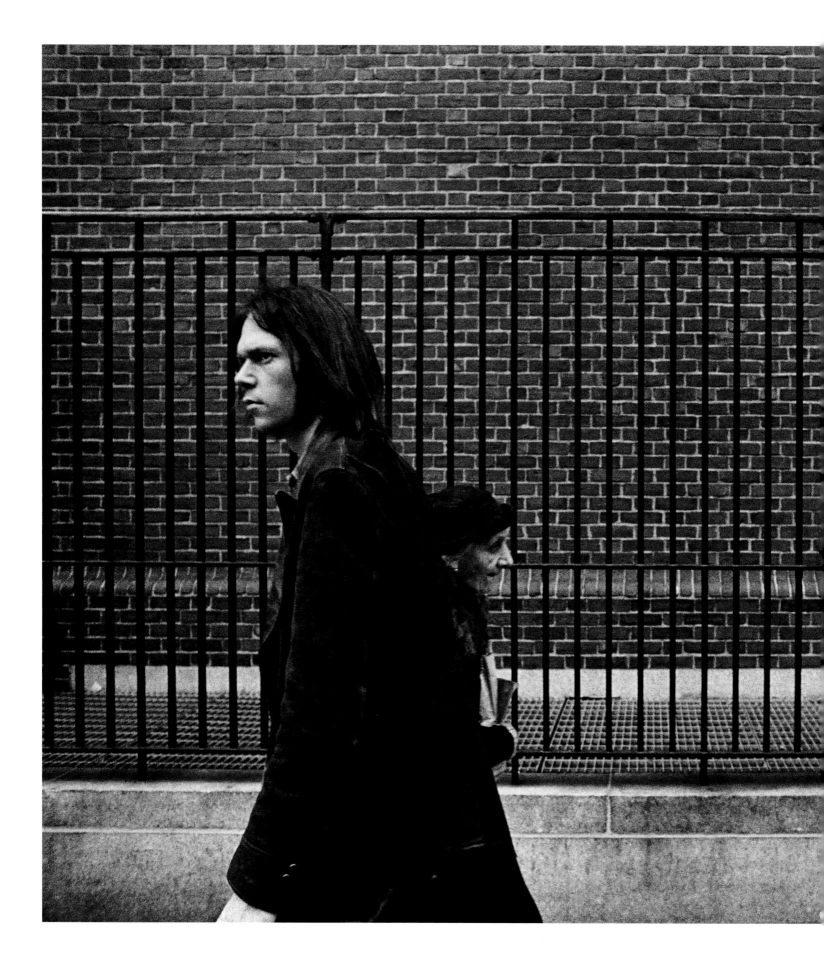

Joel Bernstein Neil Young, elderly woman, and Graham Nash in Greenwich Village, New York, New York, June 6, 1970
A cropped version of this was used for Neil Young's 1970 album, *After the Gold Rush*

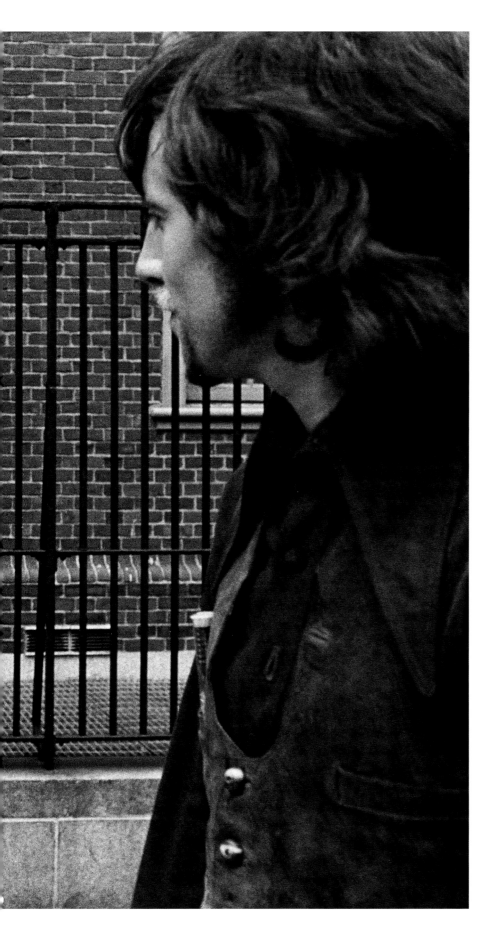

In the late morning of June 6, 1970, Neil Young, Joel Bernstein, and I were walking along the street in Greenwich Village, looking for breakfast. Joel saw this elderly lady coming toward us and quickly recognized an image that might be happening. He took one shot, solarized the print, and later showed it to Neil. Neil said instantly, "That's my album cover." So it became the album cover for the classic album of Neil's, After the Gold Rush. *Joel was just eighteen. Nice shot, kid. –GN*

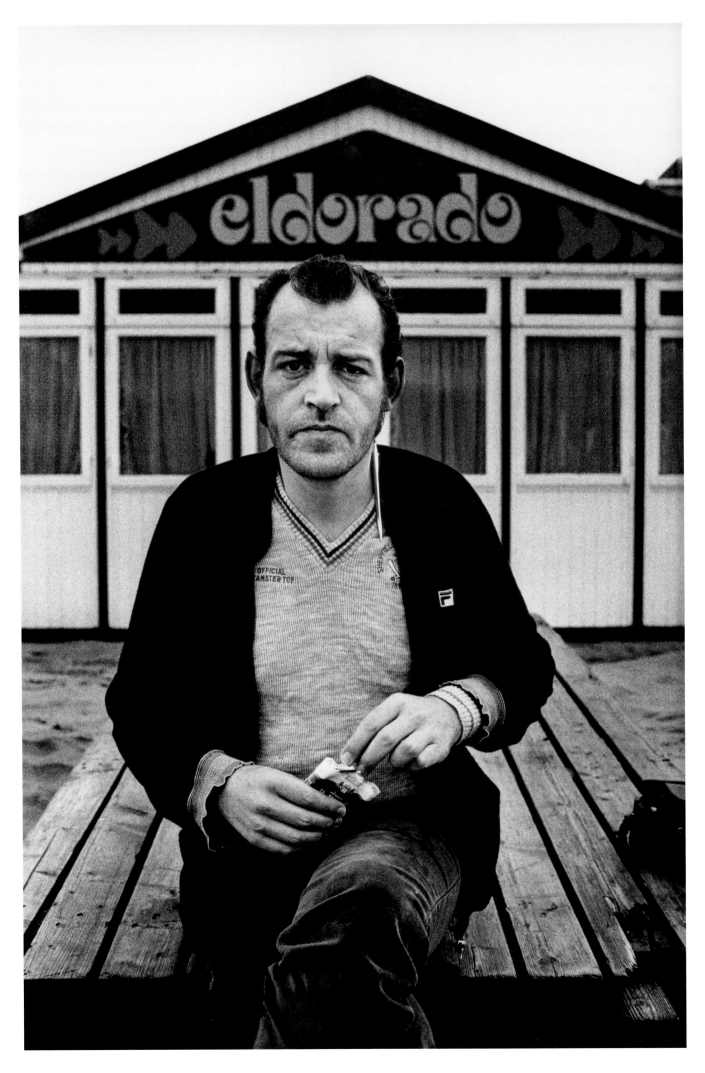

Anton Corbijn Joe Cocker at The Hague, The Netherlands, 1979

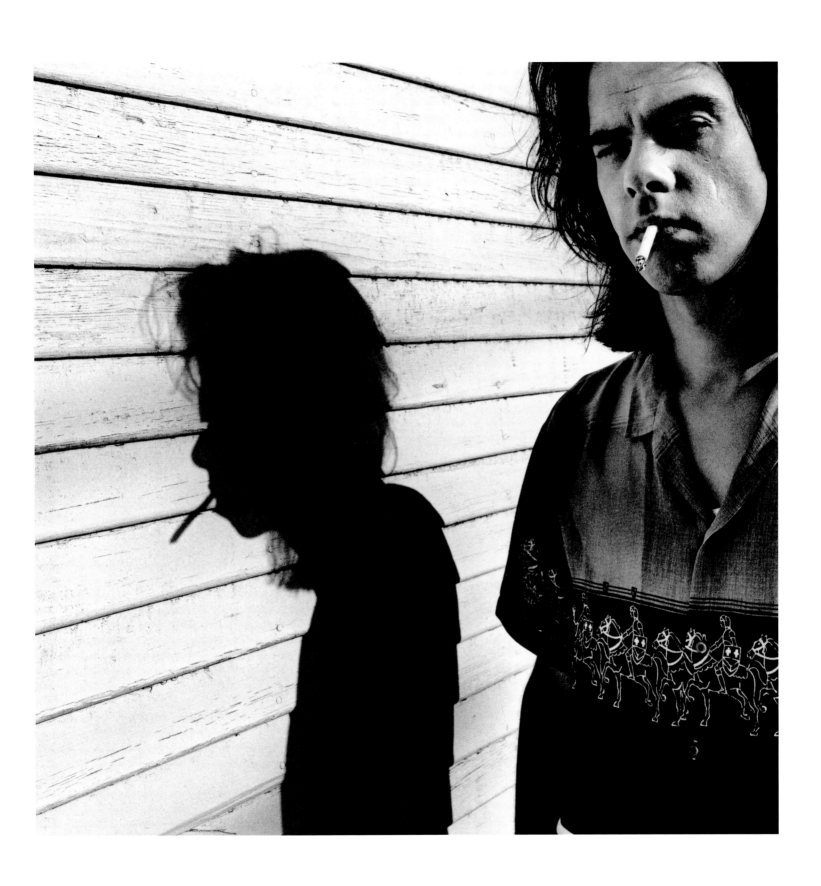

Anton Corbijn Nick Cave, Santa Monica, California, 1991

A lot of the attitude in rock 'n' roll is against the status quo, is against the people who try to confine others and try and control them. Around this banjo, Pete had written, "This machine surrounds hate and forces it to surrender," in true Woody Guthrie fashion. –GN

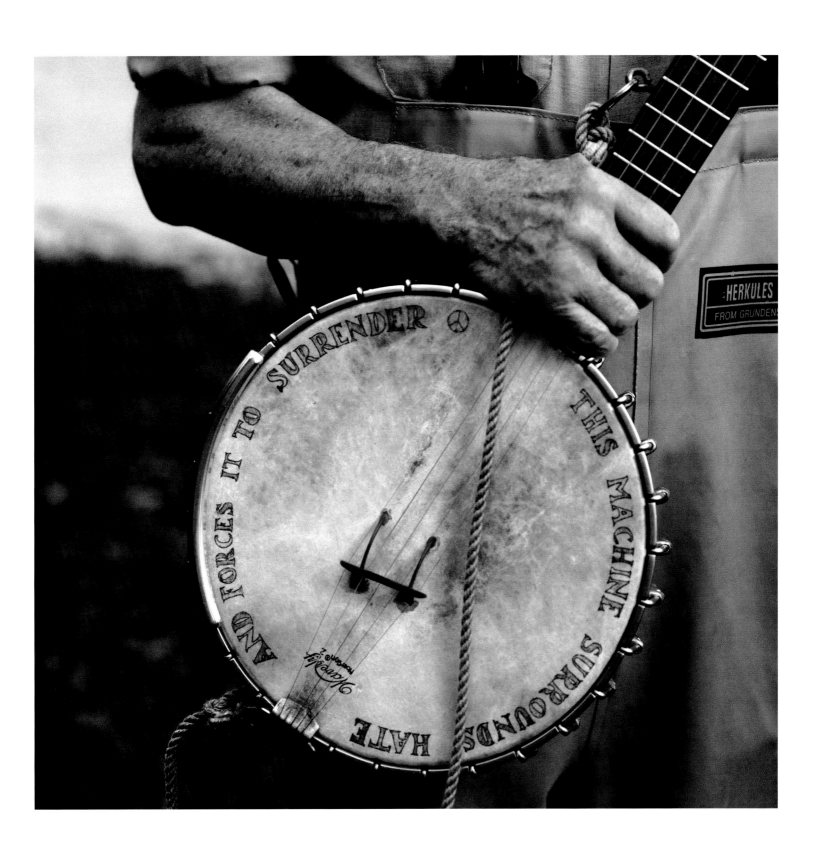

Annie Leibovitz Pete Seeger, Clearwater Revival, Croton-on-Hudson, New York, 2001

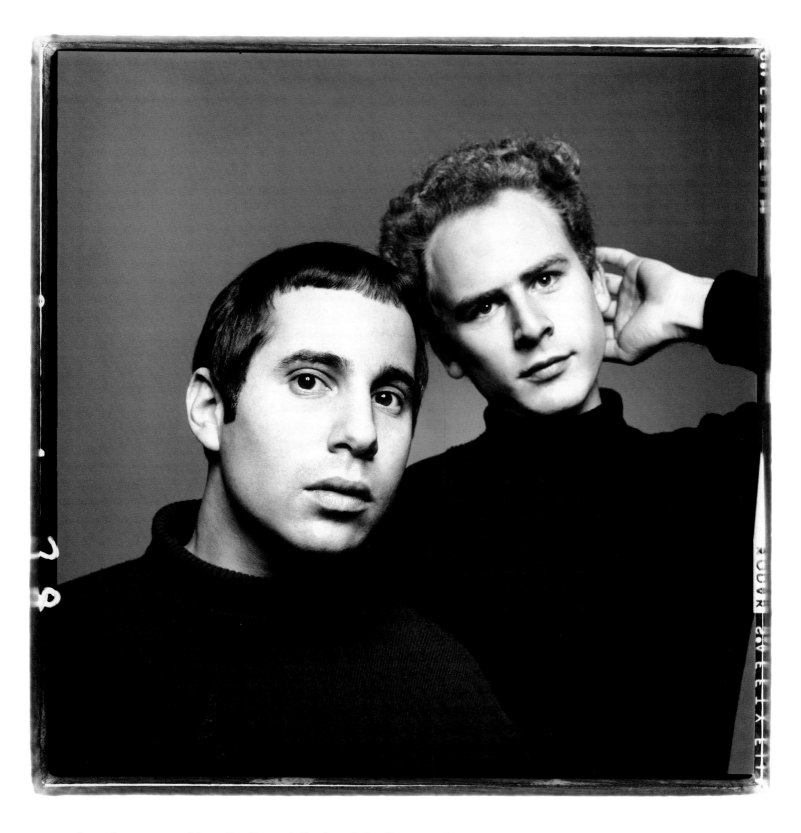

One of my personal favorite albums is Bookends *by Simon and Garfunkel. When I look at this image, it puts me right there with the music. It connects me constantly with the music I love so dearly.* —GN

Barry Feinstein Bob Dylan's hands, Edinburgh, Scotland, 1966

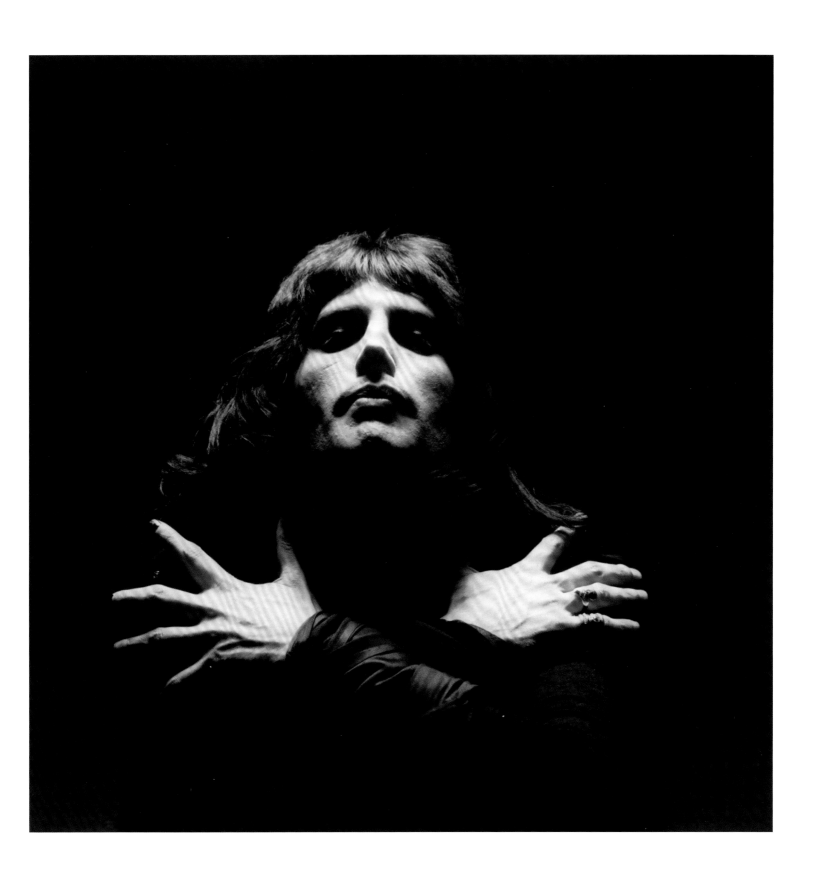

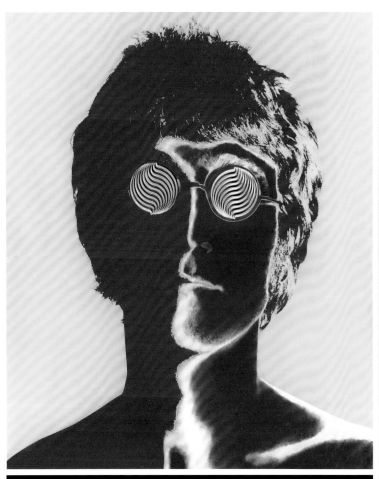
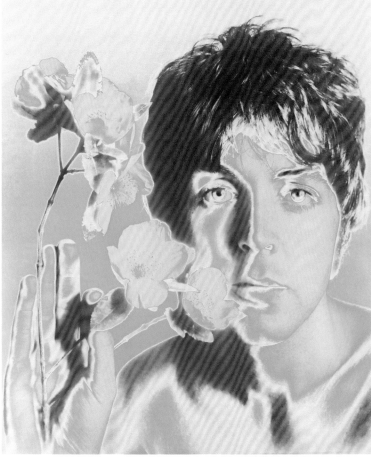
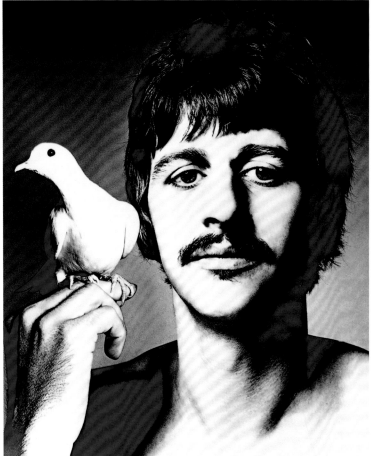
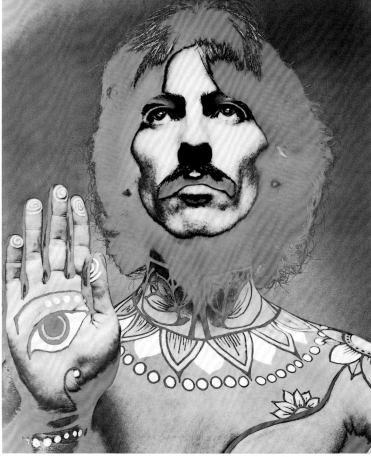

These were all the rage when first shown. It's the psychedelic Beatles, their portraits by Richard Avedon, taken in London in 1967. It was obvious that the word psychedelia *and everything surrounding it became part of the cultural language. Everybody knew what it meant to take a trip.* —GN

Richard Avedon The Beatles: John Lennon, Paul McCartney, George Harrison, Ringo Starr, musicians, London, England, August 11, 1967

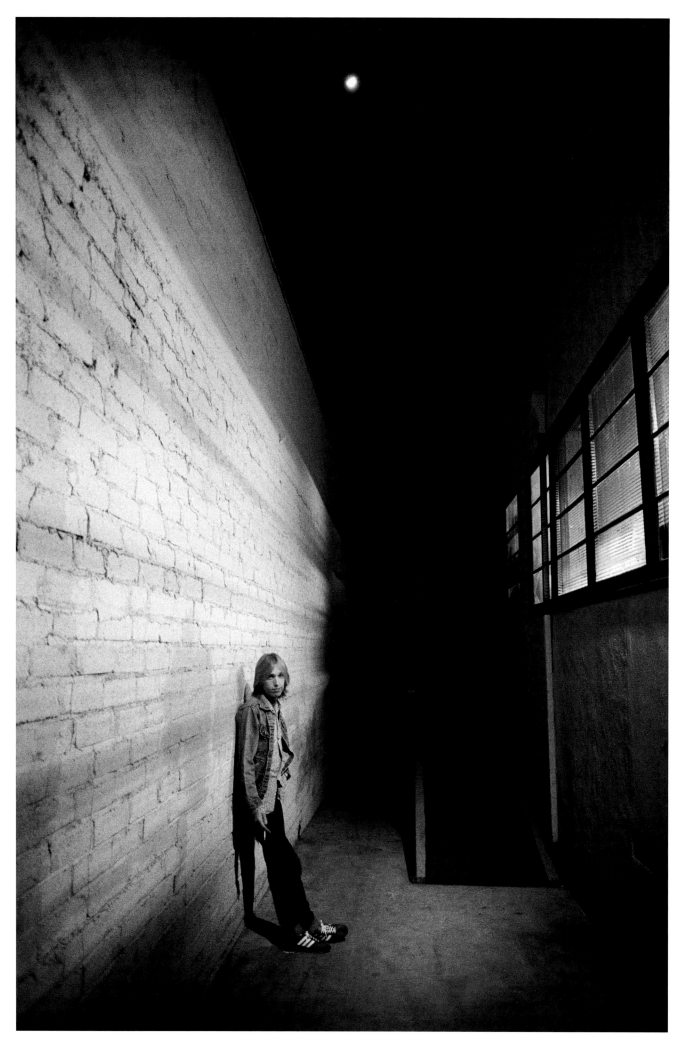

Joel Bernstein Tom Petty outside Cherokee Studios during recording sessions for his album
with the Heartbreakers, *Damn the Torpedoes*, Hollywood, California, March 9, 1979

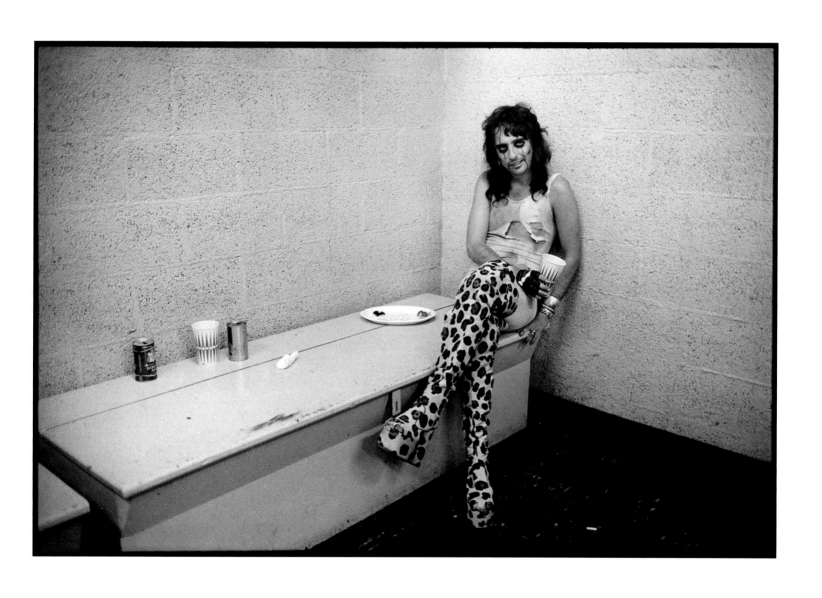

Jim Marshall Alice Cooper backstage, Denver, Colorado, 1972

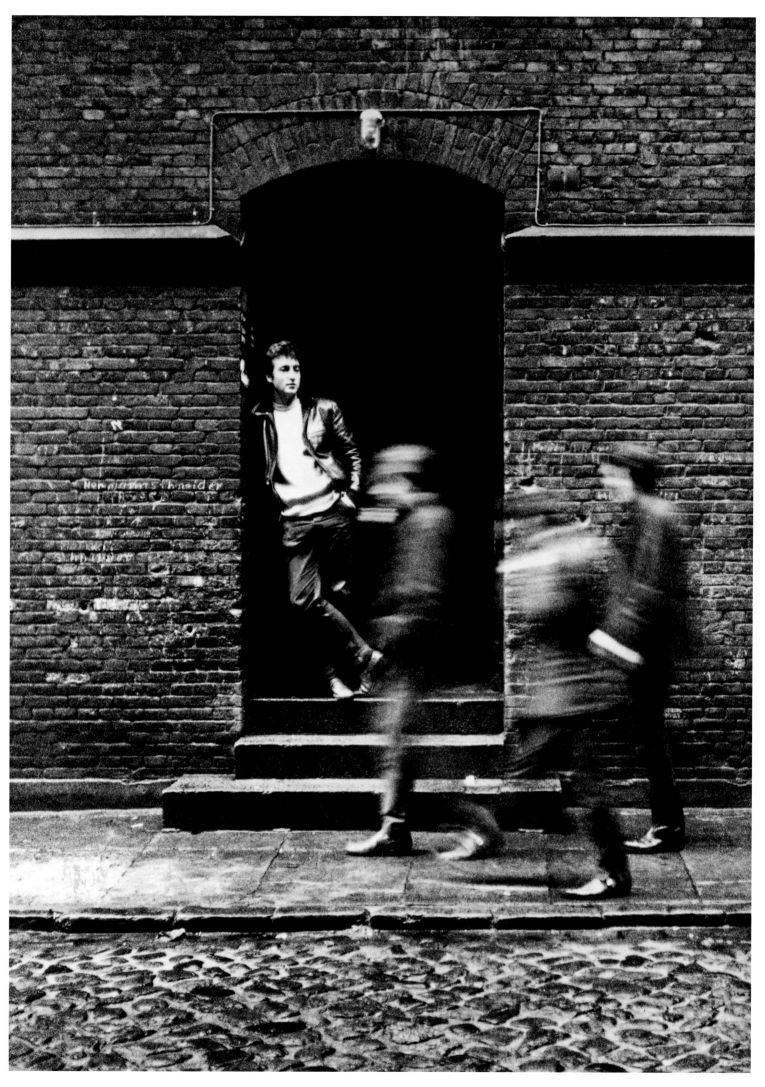

Performances

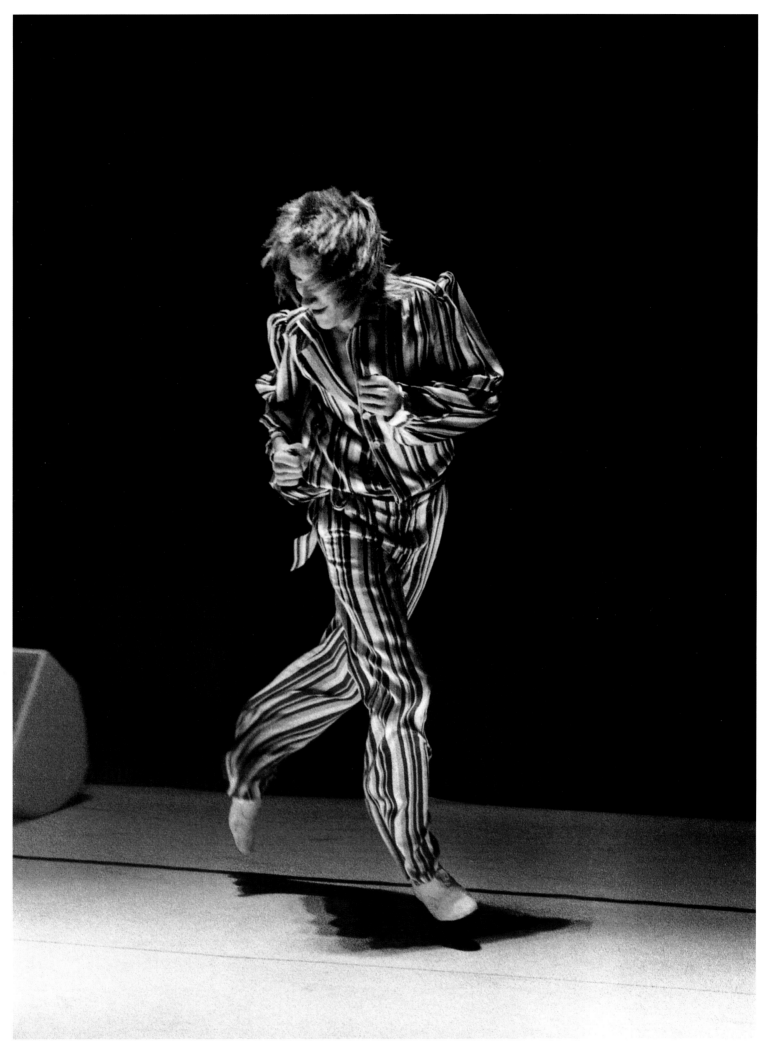

Tom Wright Rod Stewart performing during the final show by The Faces, Montreal, Canada, 1975

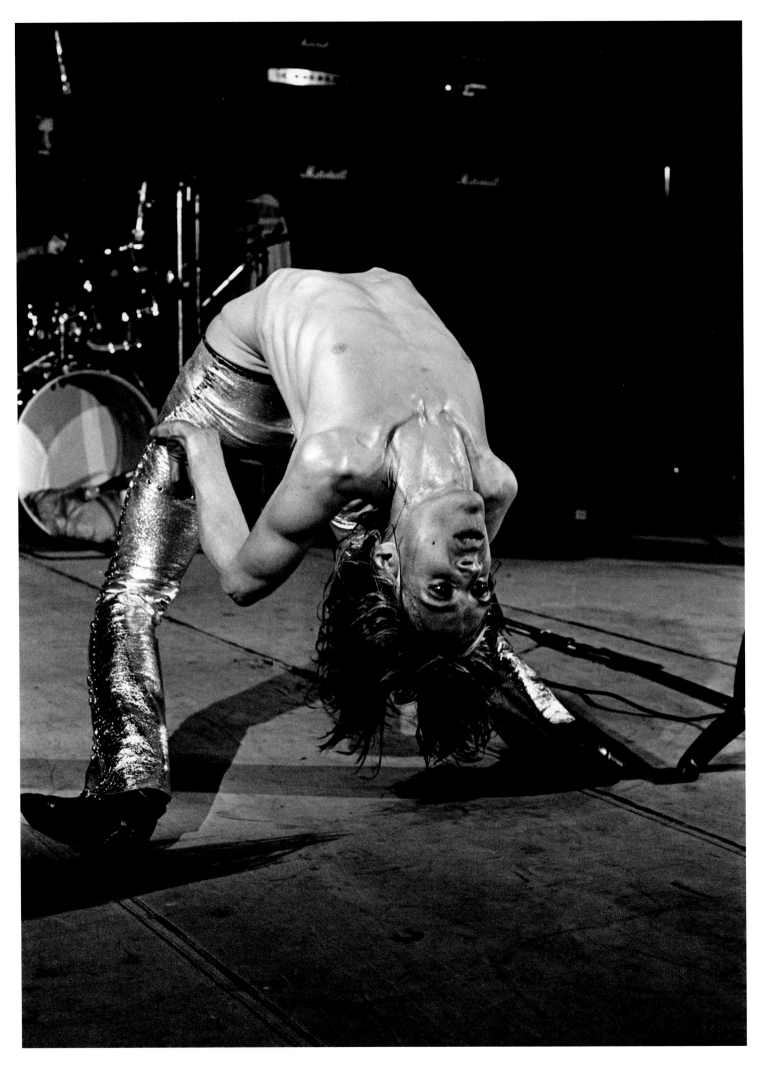

Mick Rock Iggy Pop in performance at King's Cross Cinema, London, England, 1972

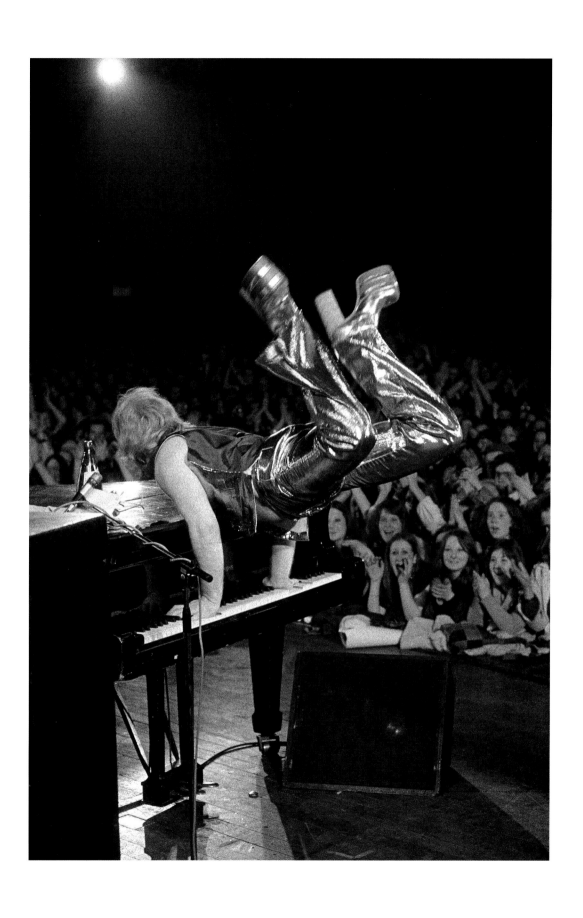

Barrie Wentzell Elton John performing "Crocodile Rock" at the
Sundown Theatre, Edmonton, North London, England, 1973

Not many musicians have the reputation for putting on more energetic performances than this man. This is Pete Townshend of The Who. I first saw The Who on British television in the very early sixties. I think they were called the High Numbers or something like that. But it was obvious they were destined for stardom. These kids had so much energy it was insane. –GN

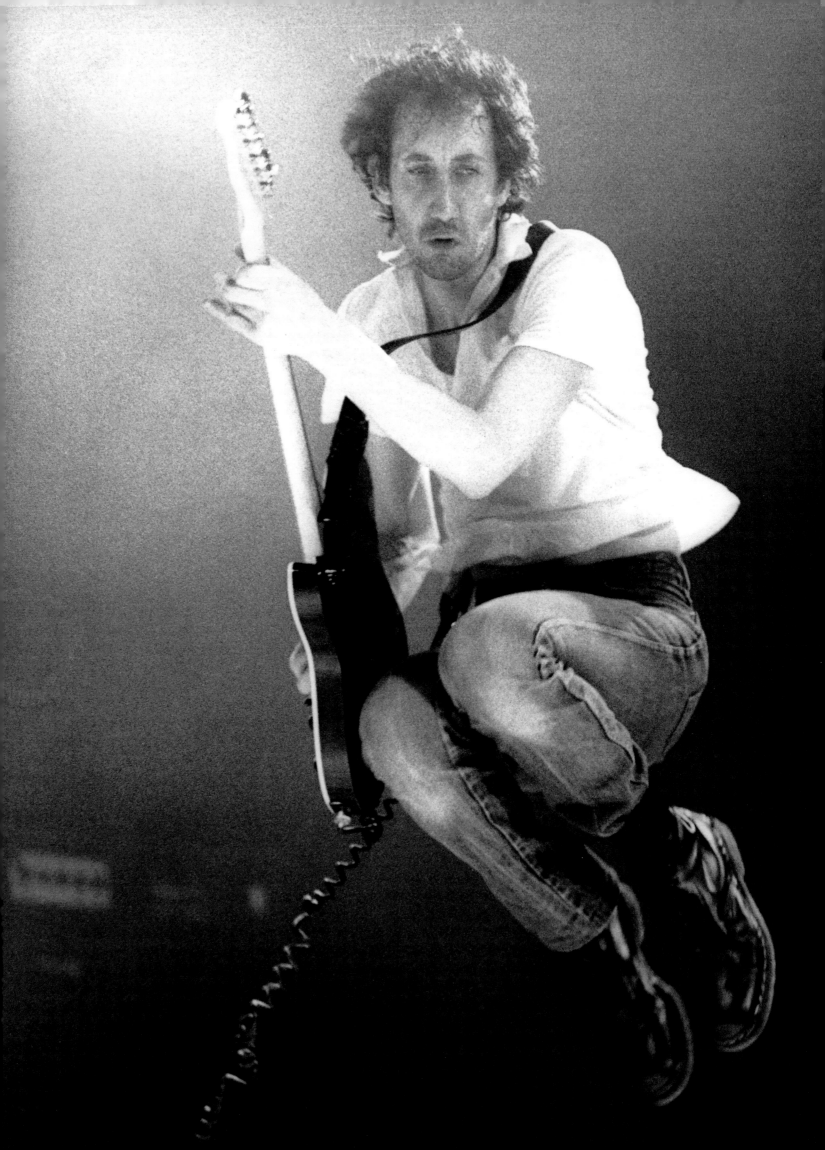

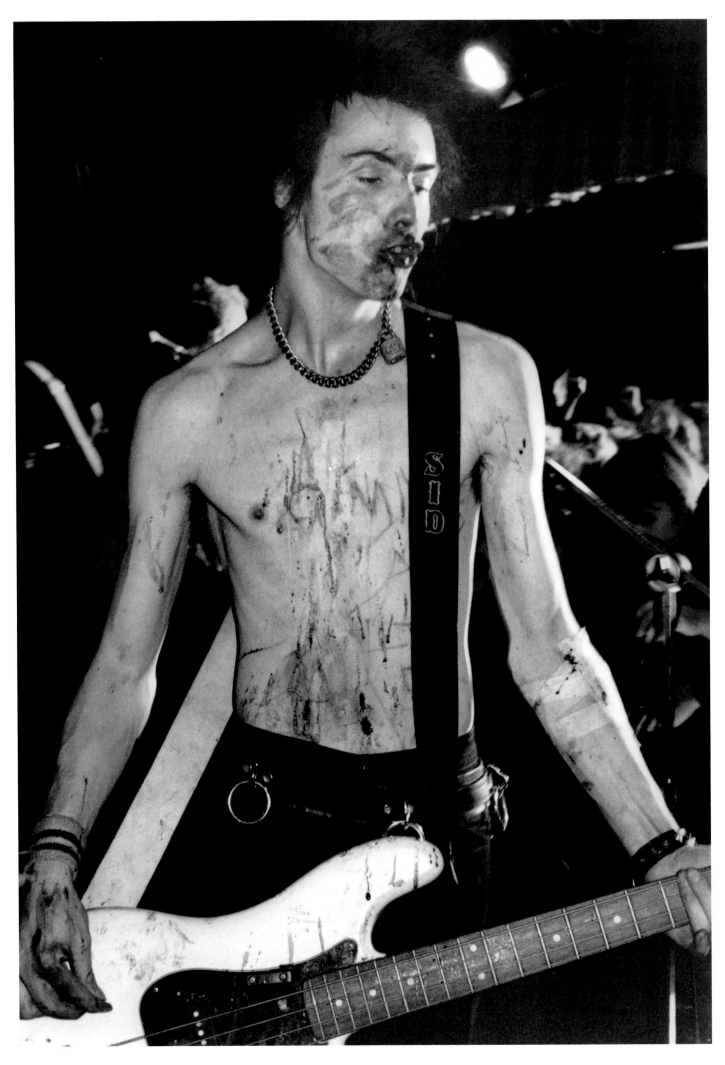

Bob Gruen Sid Vicious at the Longhorn Ballroom, Dallas, Texas, January 10, 1978

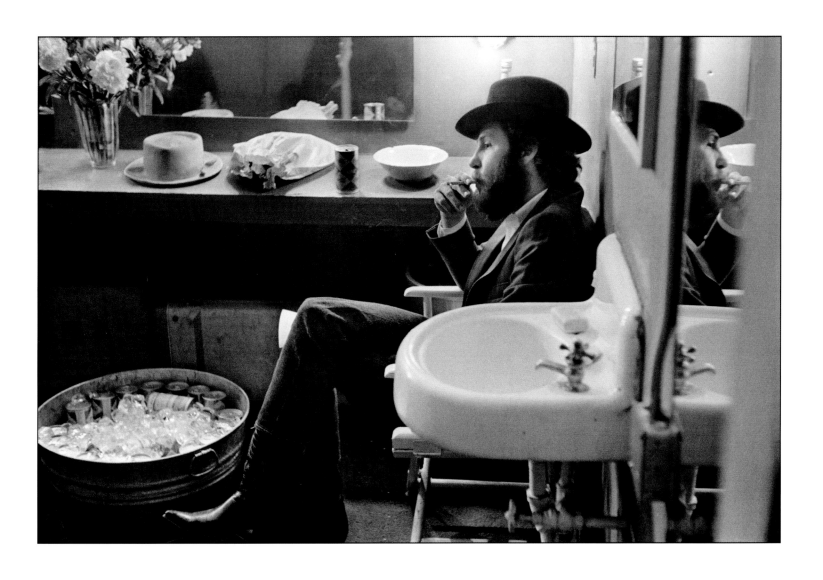

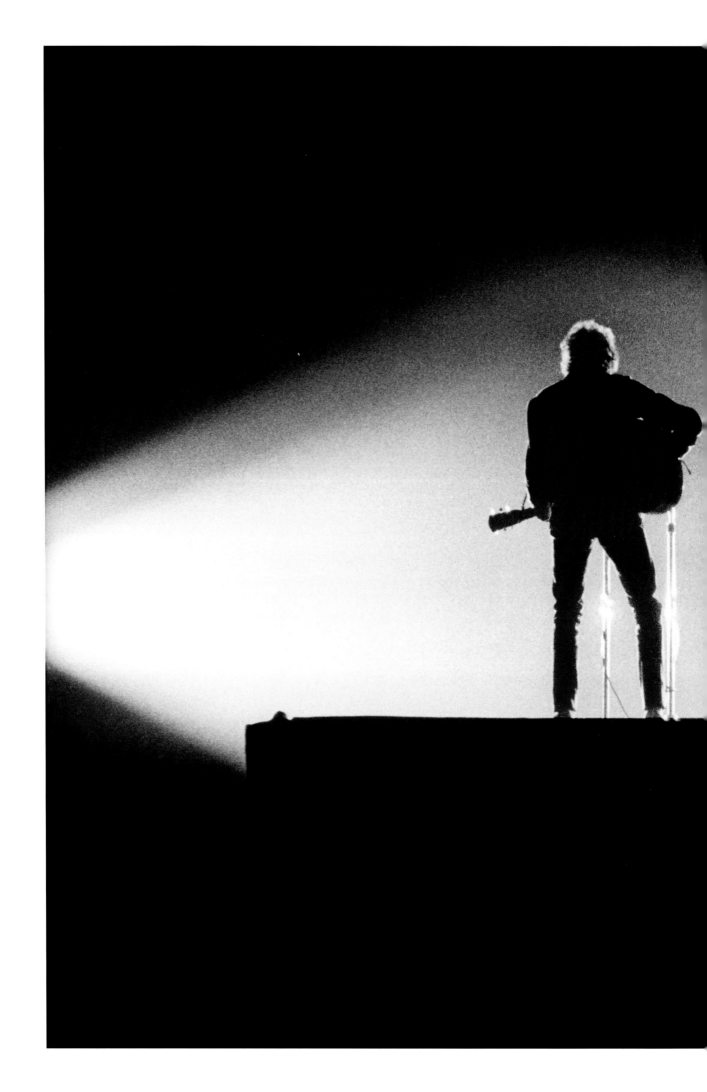

Daniel Kramer *Bob Dylan and Joan Baez in Crossed Lights*, New Haven, Connecticut, March 6, 1965

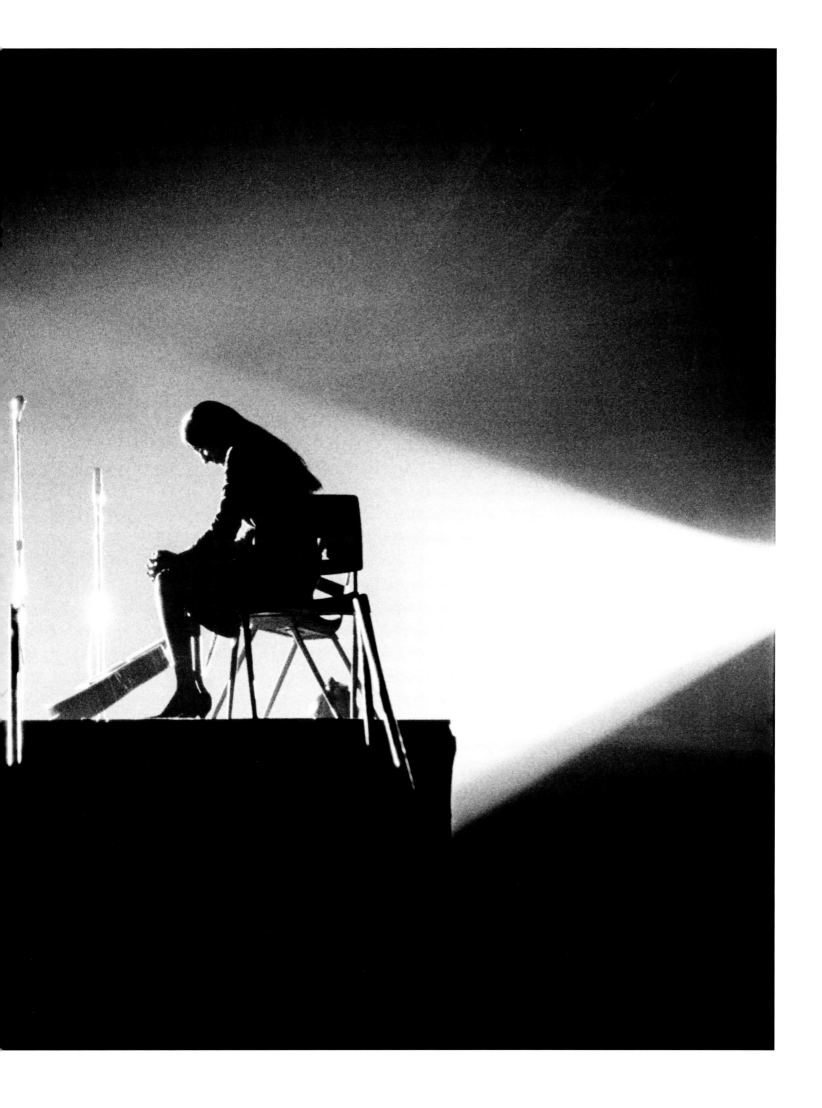

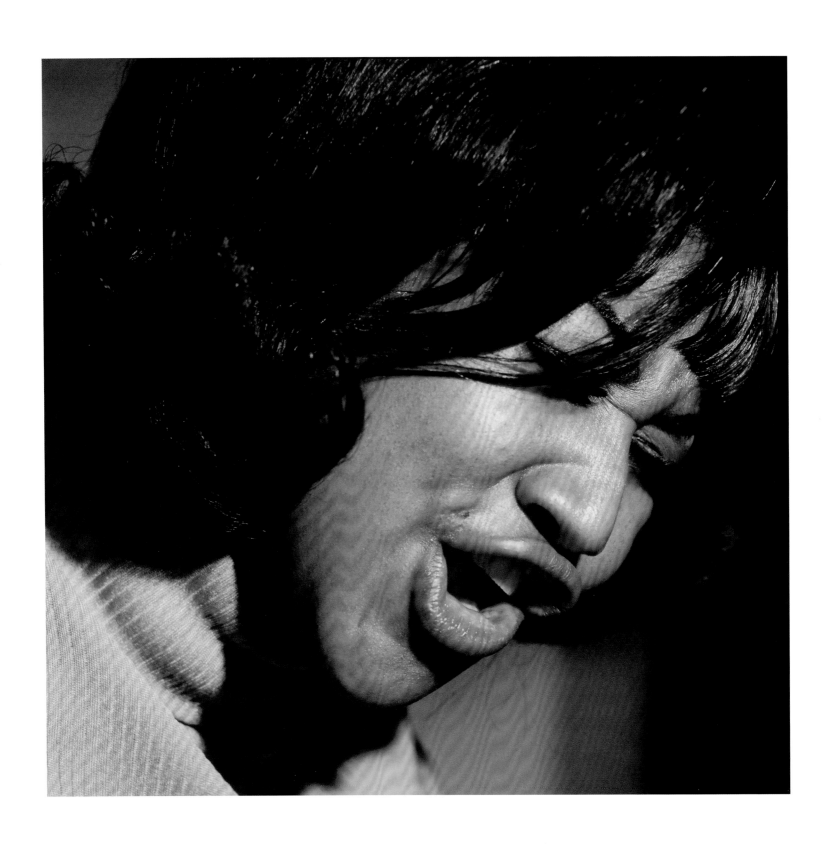

Lee Friedlander Aretha Franklin, location unknown, 1968

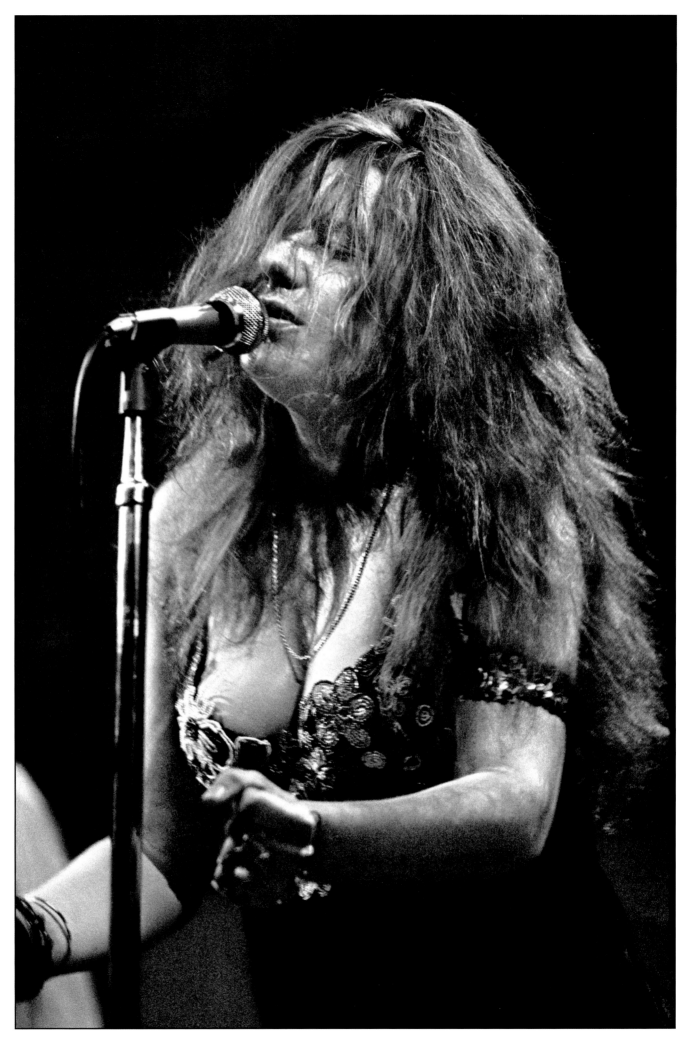

Elliott Landy Janis Joplin in performance at the opening
of the Fillmore East, New York, New York, March 8, 1968

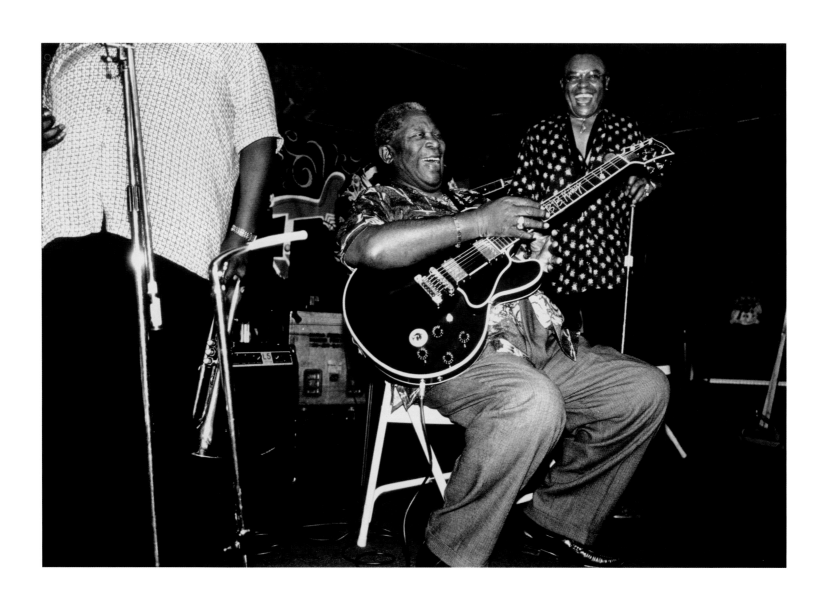

One of the great things about being a musician, one of the perks of the trade so to speak, is the joy. Look at the joy on B.B.'s face. Look at the joy on the faces of the musicians standing behind him. What a wonderful job we have. —GN

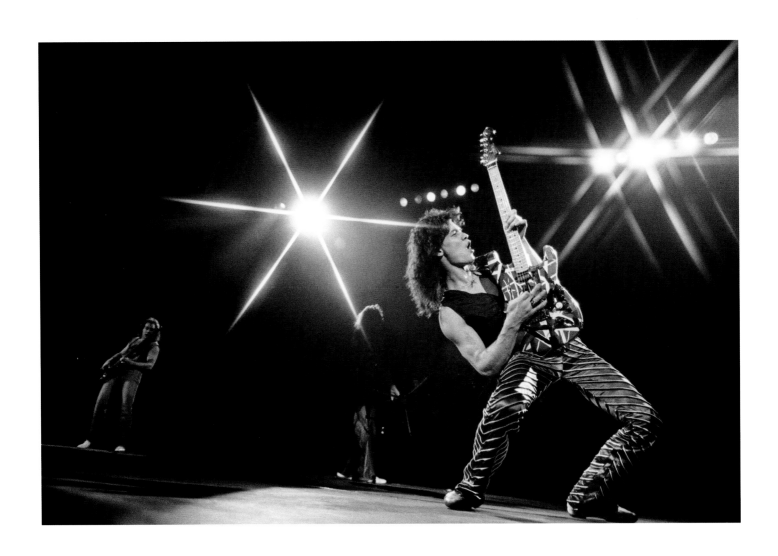

Lynn Goldsmith Eddie Van Halen in performance, Los Angeles, California, 1979

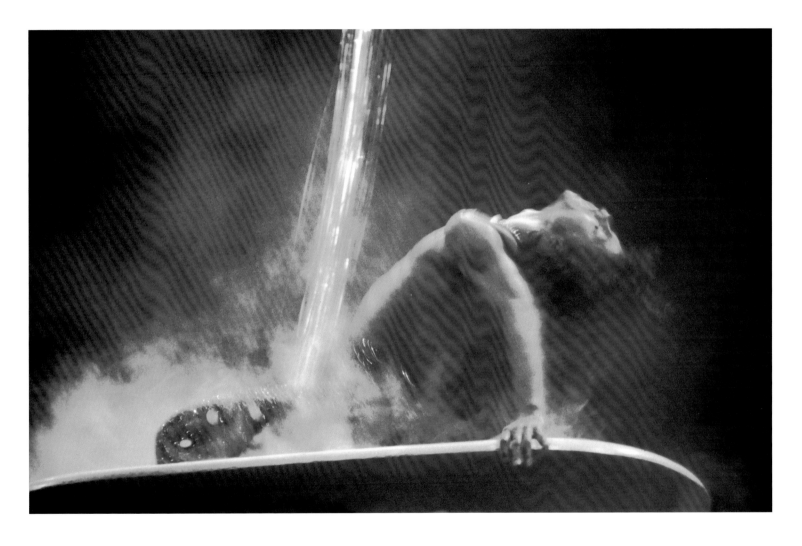

My own opinion is that the subject of this photograph is a genius. This man gives all, every single performance, every single song, every single night. I once saw him in concert and was truly astounded at his talent. —GN

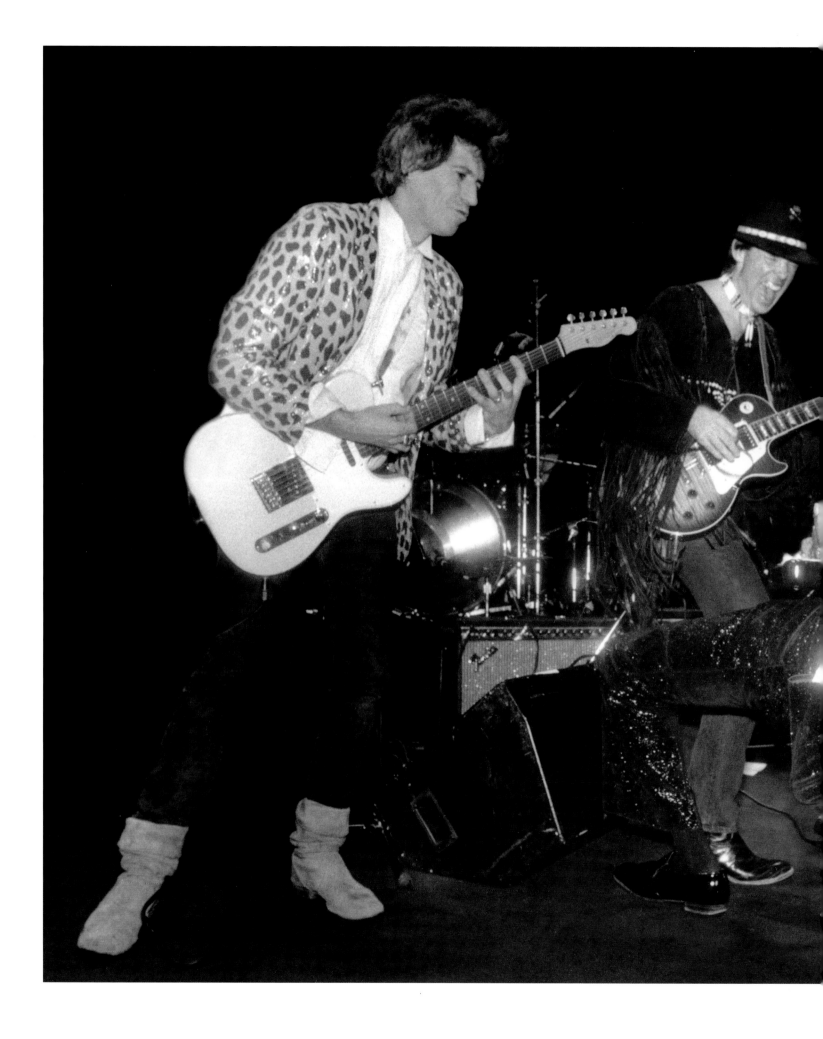

Lynn Goldsmith Keith Richards, Neil Young, and Chuck Berry perform at the first Rock and Roll
Hall of Fame induction ceremony, New York, New York, January 23, 1986

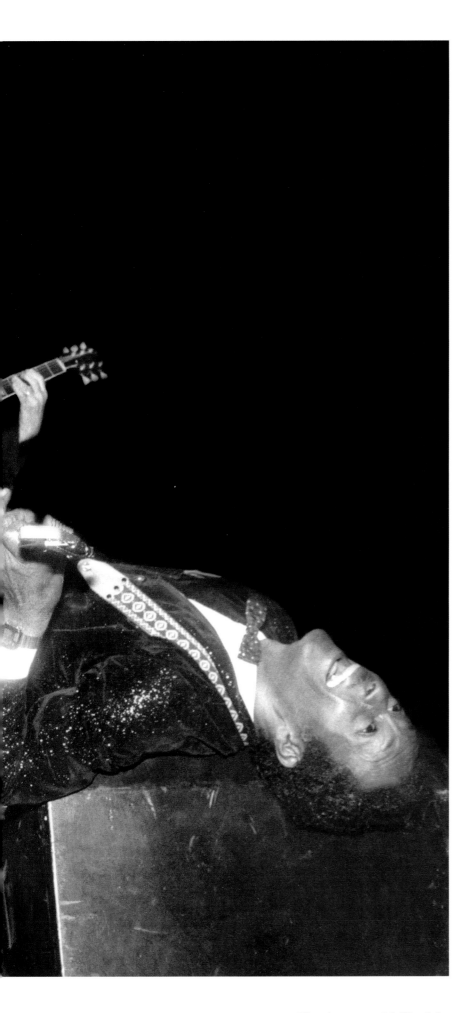

Chuck once said, "Rock is so good to me. Rock is my child and my grandfather." –GN

Bill Haley & His Comets were a great influence on my life. As a matter of fact, my friends know this about me, but I keep the ticket stub to the Bill Haley concert in Manchester in 1958 in my wallet to this day. –GN

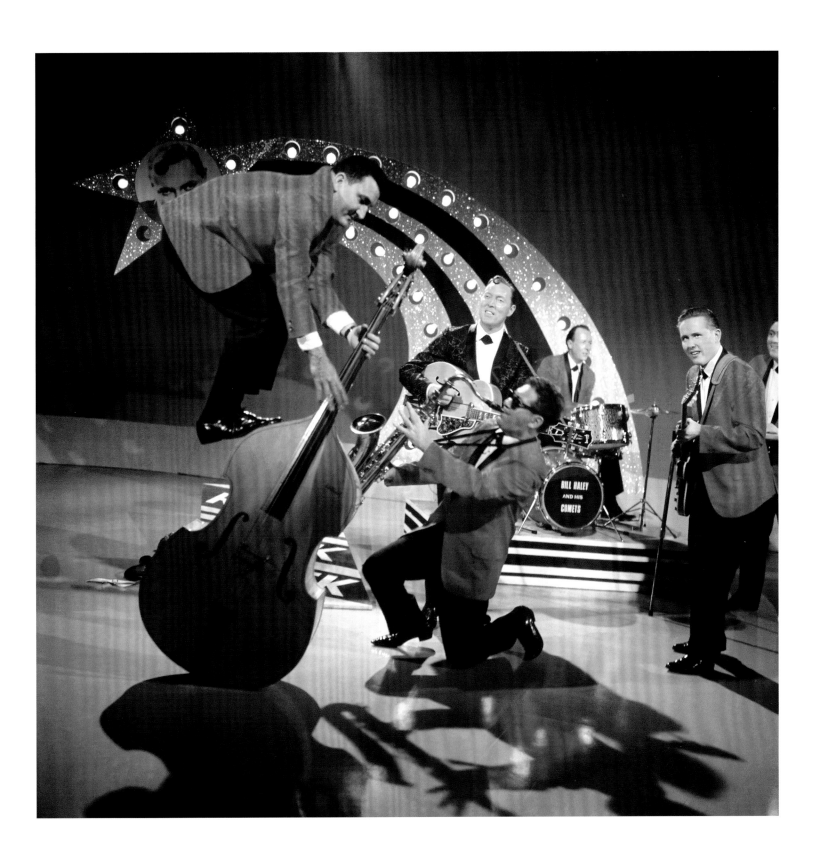

David Redfern Bill Haley & His Comets in performance
on *Thank Your Lucky Stars*, Aston Studios, Birmingham, England, 1964

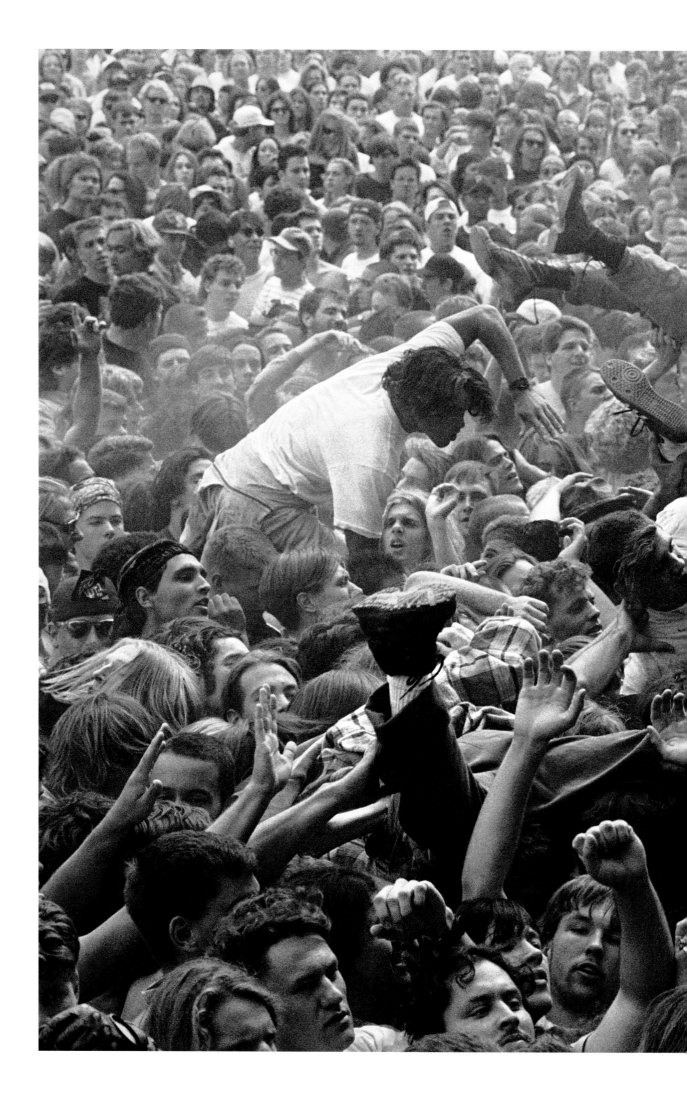

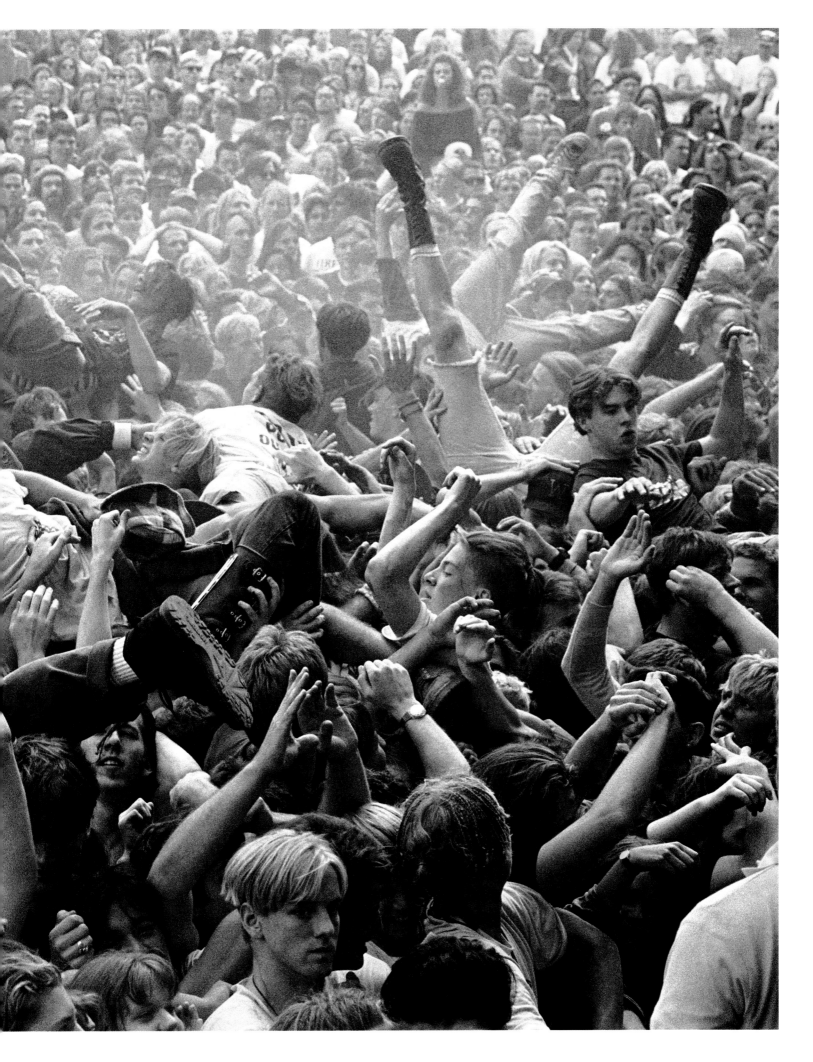

Charles Peterson Crowd with body surfers during Mudhoney's set at the
KNDD Endfest, Kitsap County, Washington, 1991

To a large degree, I think this is what it's all about, this moment of contact between musicians and the audience. —GN

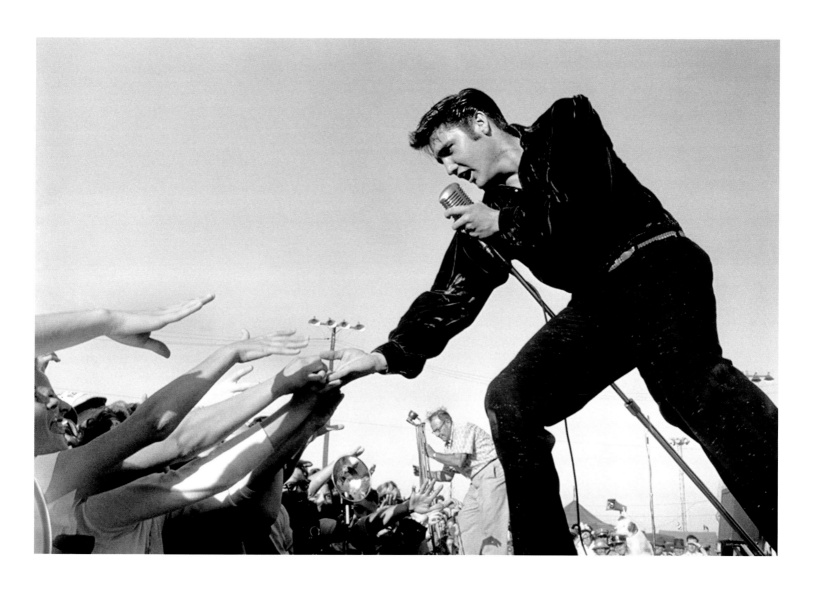

Roger Marshutz Elvis Presley in performance at the Mississippi-Alabama
State Fair and Dairy Show, Tupelo, Mississippi, September 28, 1956

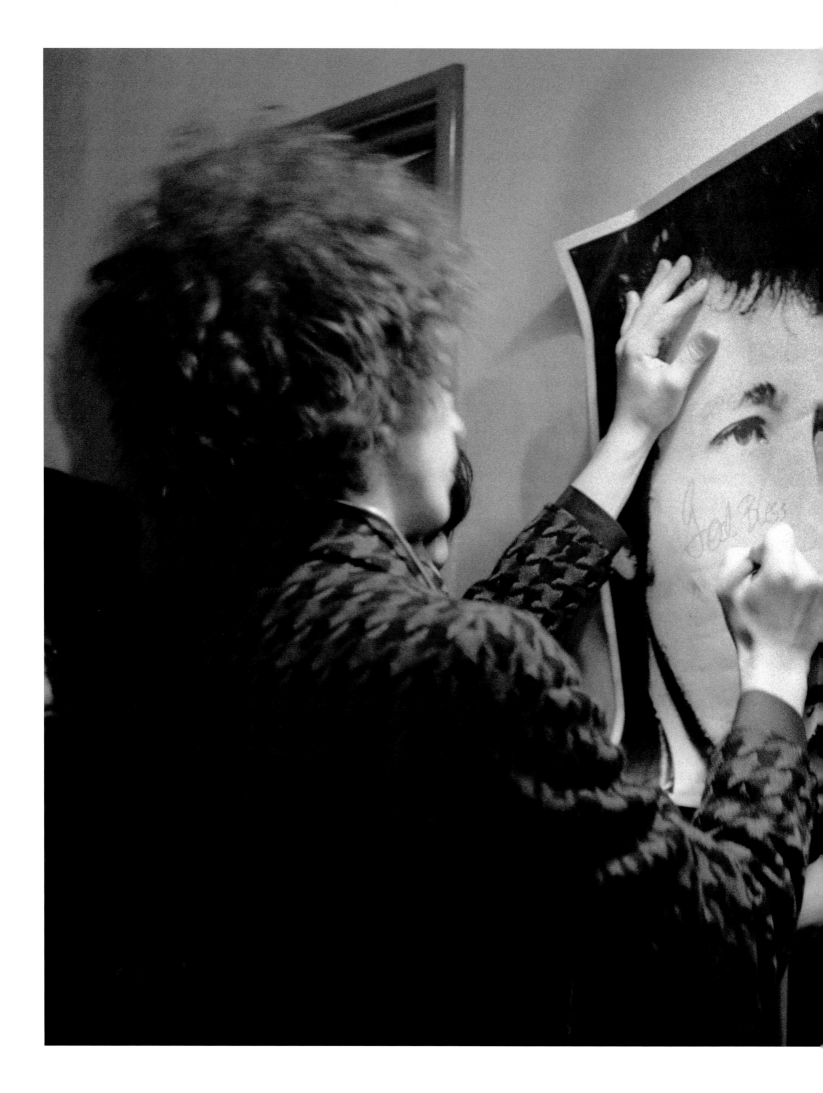

Barry Feinstein Bob Dylan signing a poster at the Olympia Concert Hall, Paris, France, 1966

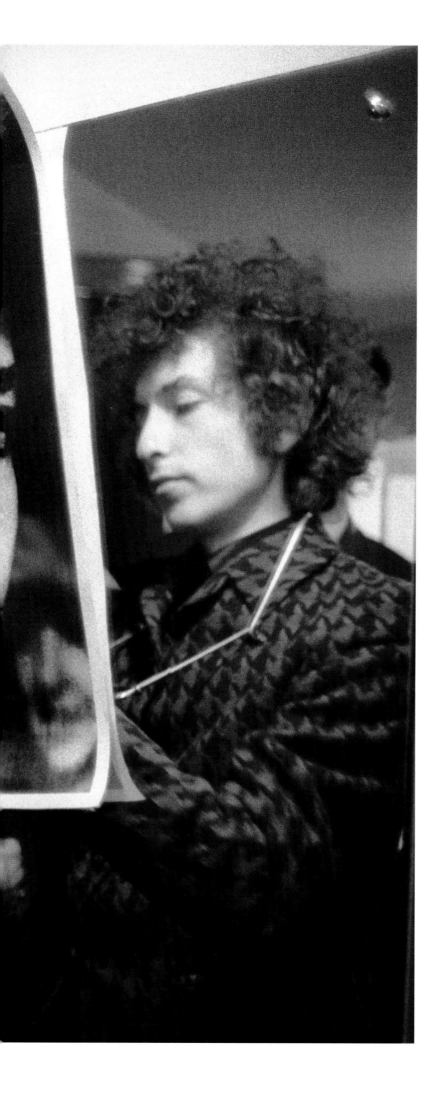

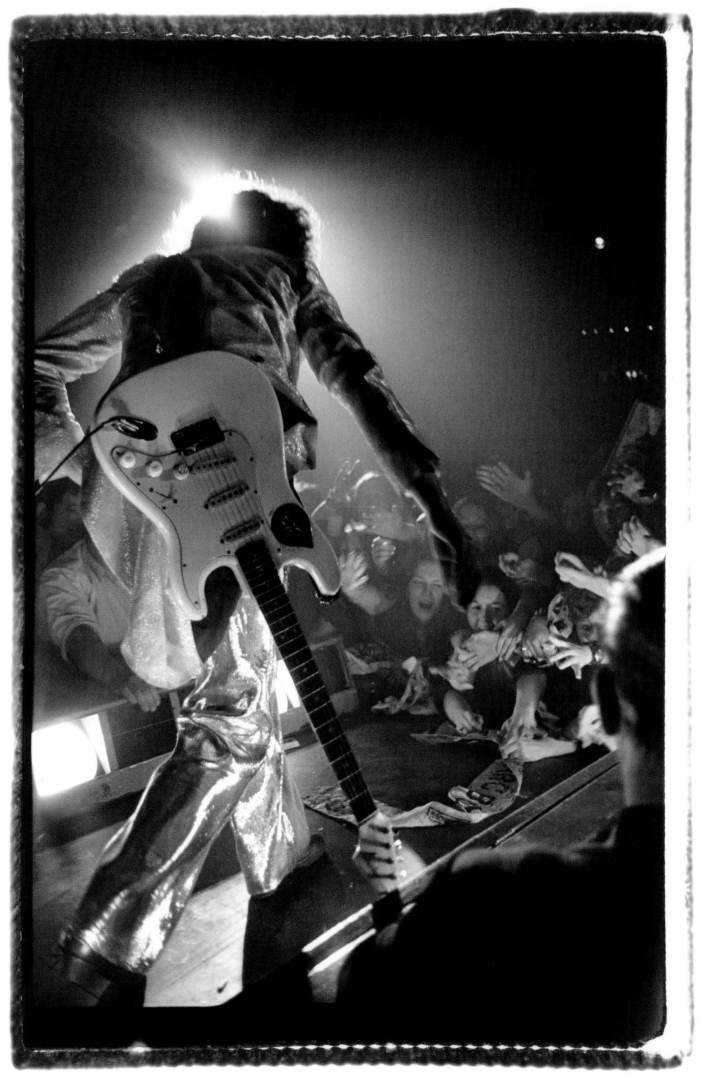

Charles Peterson Krist Novoselic, Kurt Cobain, and Chad Channing of Nirvana in performance at Raji's, Hollywood, California, February 15, 1990

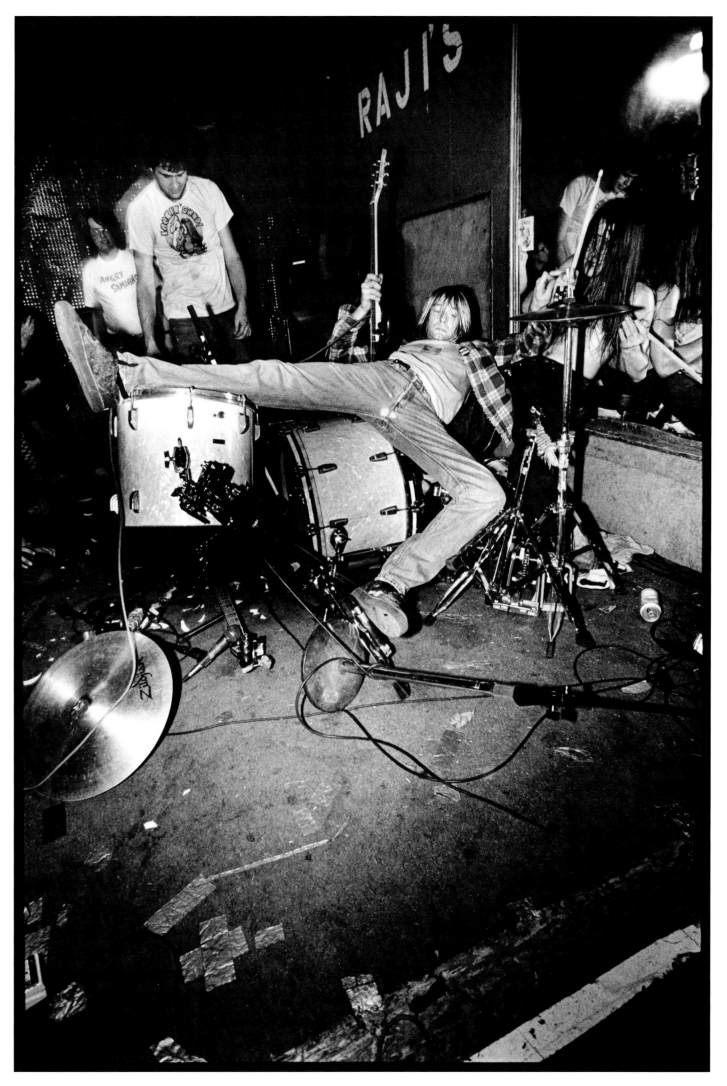

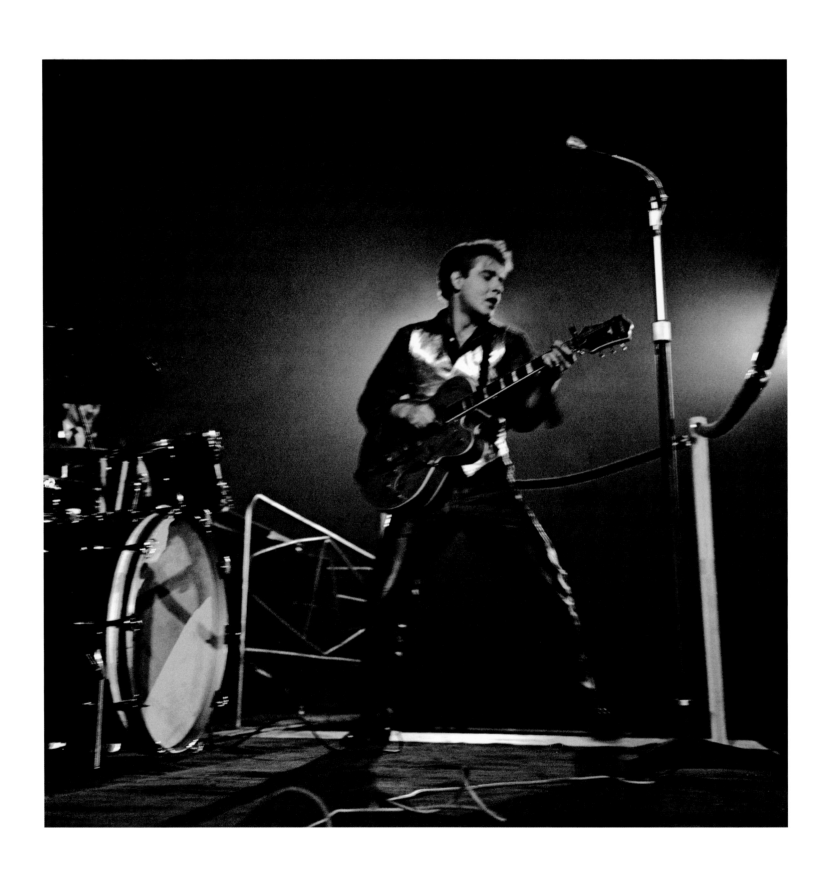

Harry Hammond Eddie Cochran in performance, Wembley, London, England, 1960

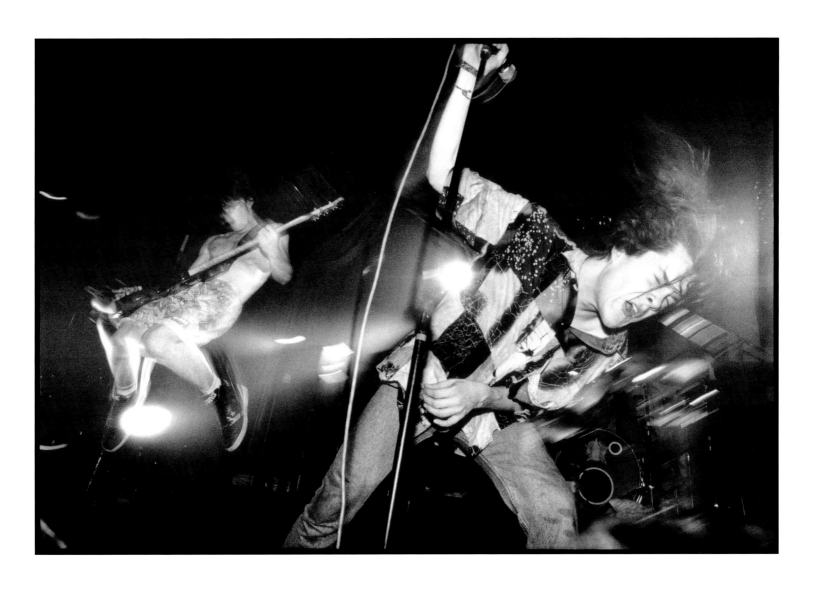

Ed Sirrs Ned's Atomic Dustbin in performance at Kilburn National, London, England, 1991

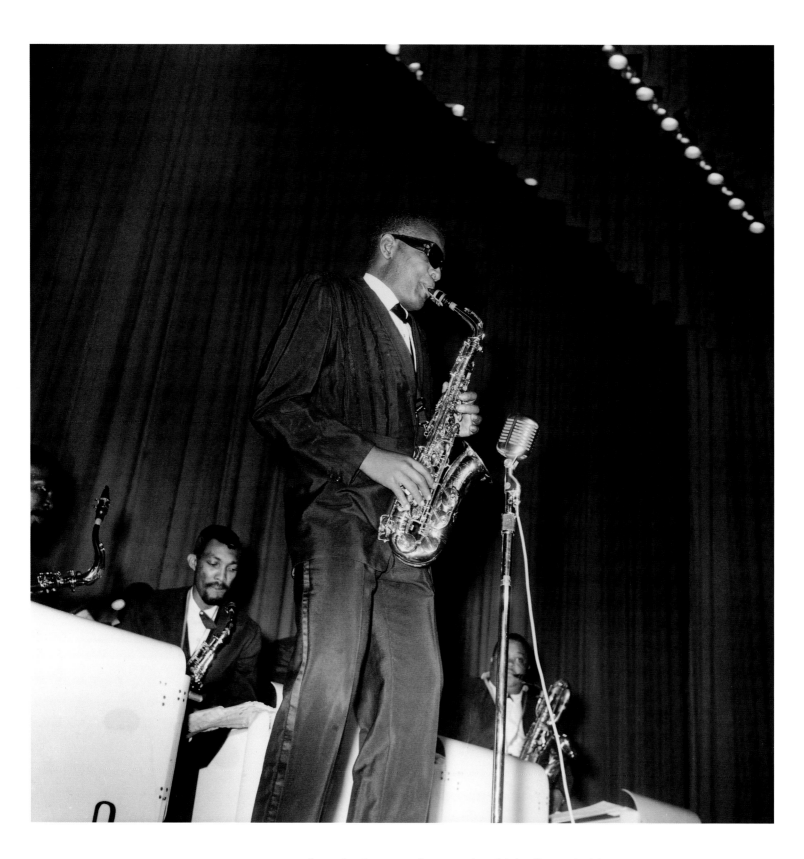

In reviewing many images of rock 'n' roll people, blues people, gospel people, country people for this project, I was looking for shots of Ray Charles. And I found this one, an incredibly unusual one because it's Ray playing the alto sax. When did you ever see a picture of Ray Charles playing the alto sax? –GN

Ernest Withers Ray Charles and Hank Crawford in performance at City Auditorium, Memphis, Tennessee, circa 1961

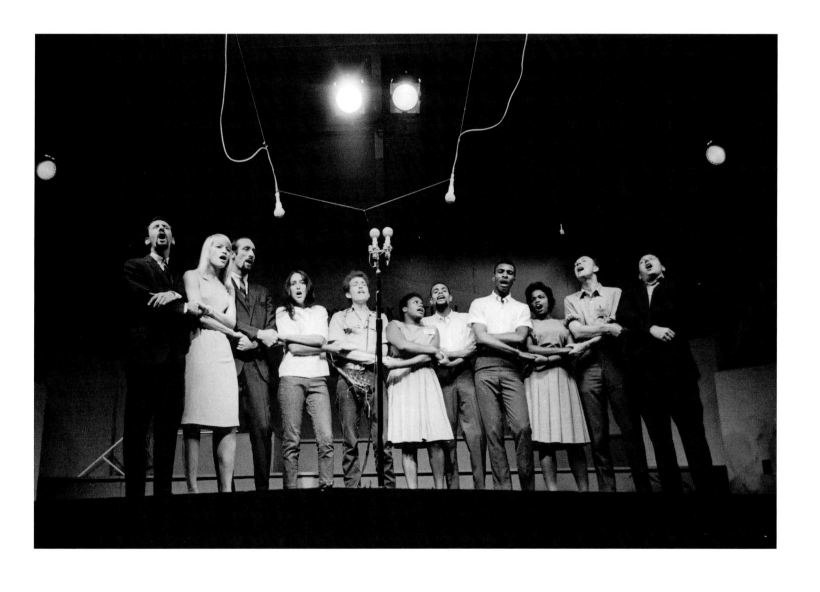

Jim Marshall Peter Yarrow, Mary Travers, Noel "Paul" Stookey, Joan Baez, Bob Dylan, The Freedom Singers, Peter Seeger, and Theodore Bikel perform "We Shall Overcome" at the Newport Folk Festival, Newport, Rhode Island, July 28, 1963

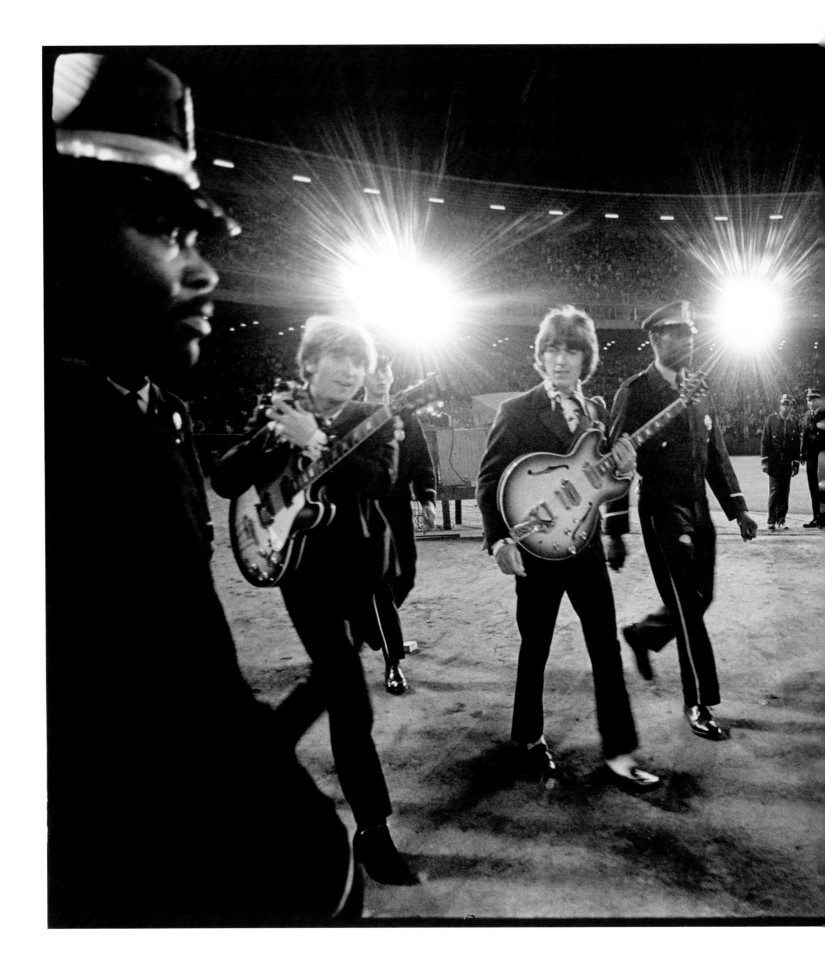

Jim Marshall The Beatles—John Lennon, George Harrison, Paul McCartney, and Ringo Starr—walk to the stage at Candlestick Park, San Francisco, California, August 29, 1966

This would turn out to be their final public concert.

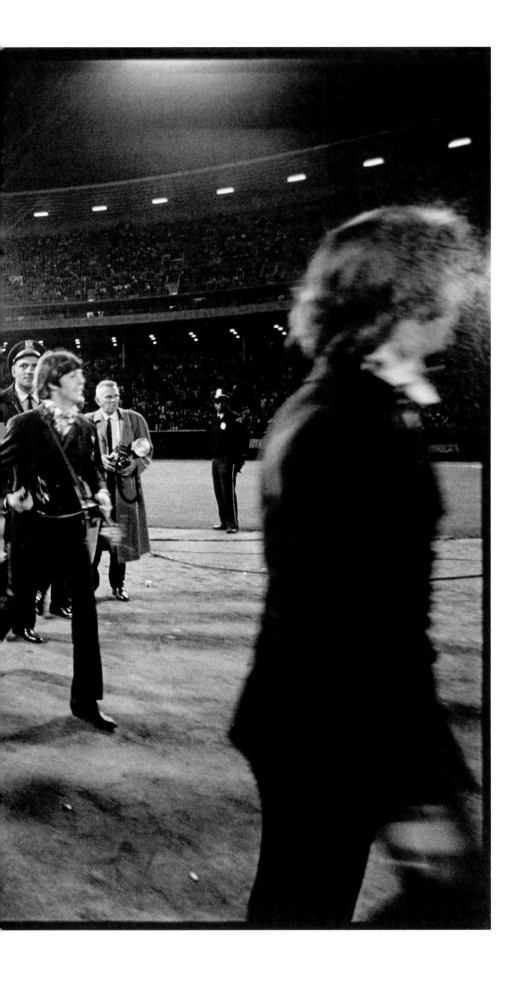

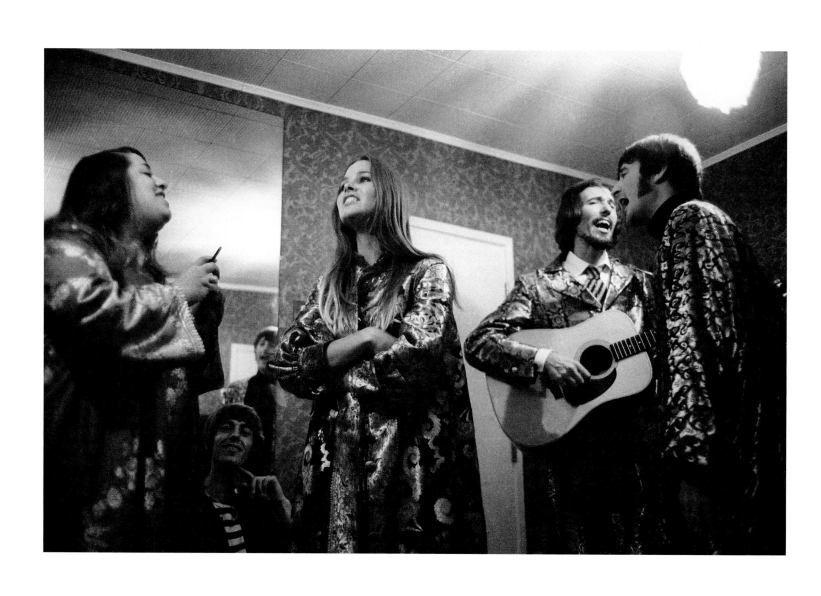

Henry Diltz The Mamas & the Papas–Cass Elliot, Michelle Phillips, Denny Doherty, and John Phillips–backstage at the Hollywood Bowl, Los Angeles, California, 1967

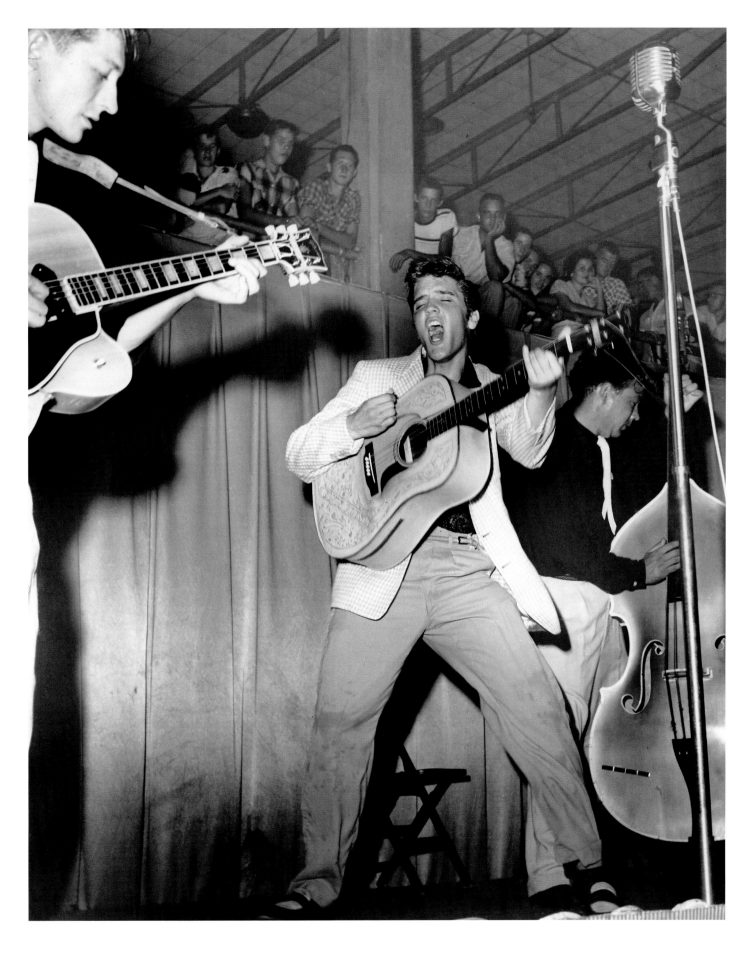

This image was used as the cover of a 45. I bought this record myself when I was a kid in Manchester in the north of England. Incredible energy once again. This is a great photograph of Elvis. —GN

Robertson & Fresh Photo Company Elvis Presley
in performance, Tampa, Florida, July 31, 1955

When I was 16 years old, the very first record I ever bought, with my own money, was "Be-Bop-a-Lula" by Gene Vincent. That record changed my life. I actually ended up later becoming a recording artist for Capitol Records, not because of the money that they would pay me, but because they would let me loose in the basement in the studio with the original Gene Vincent two-tracks. I was in heaven. –GN

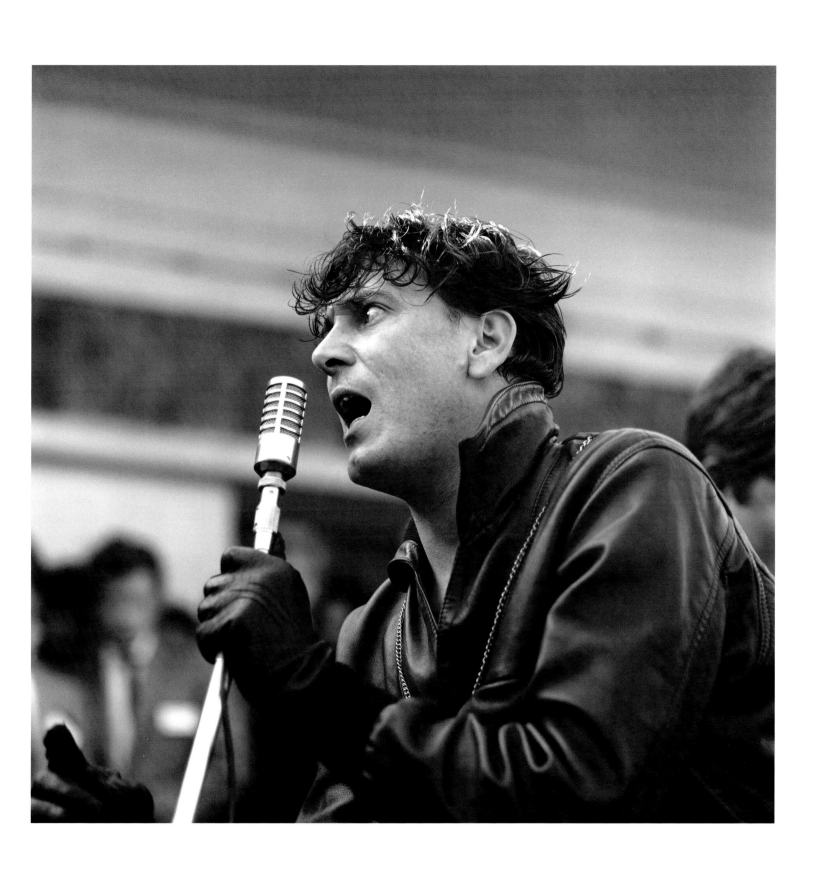

David Redfern Gene Vincent in performance, Calais Harbor, France, 1959

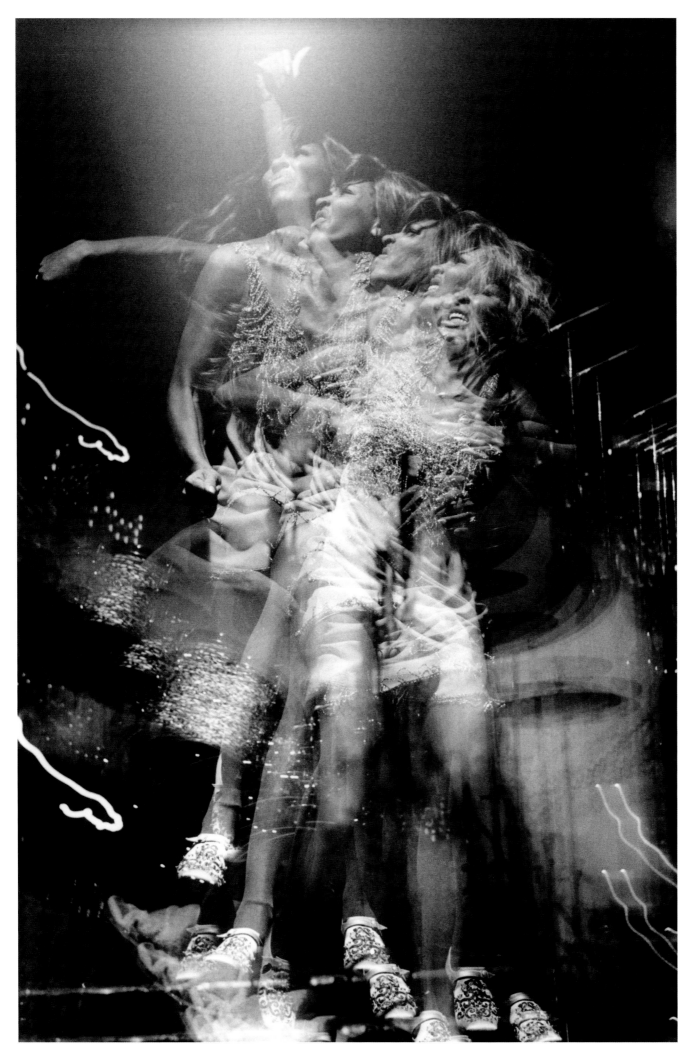

Bob Gruen Tina Turner in performance at the Honkamonka Room, Queens, New York, July 1970

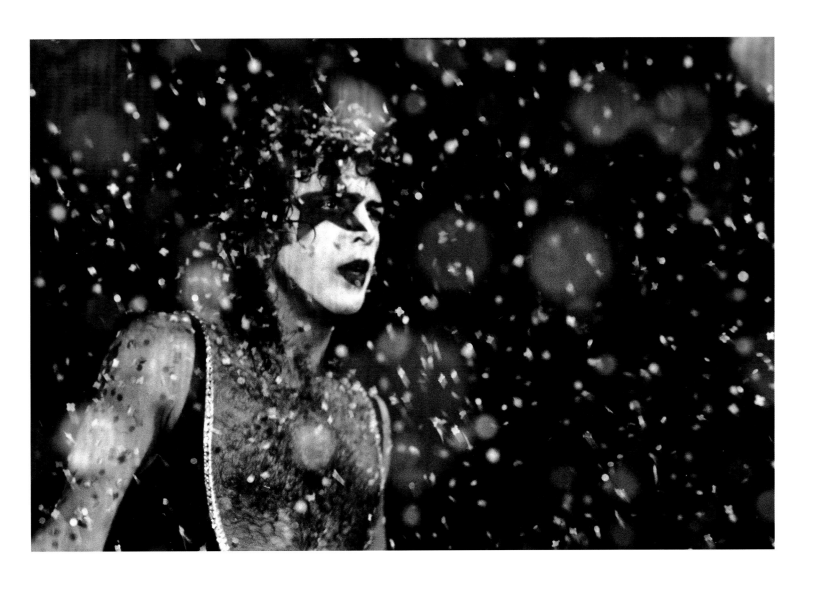

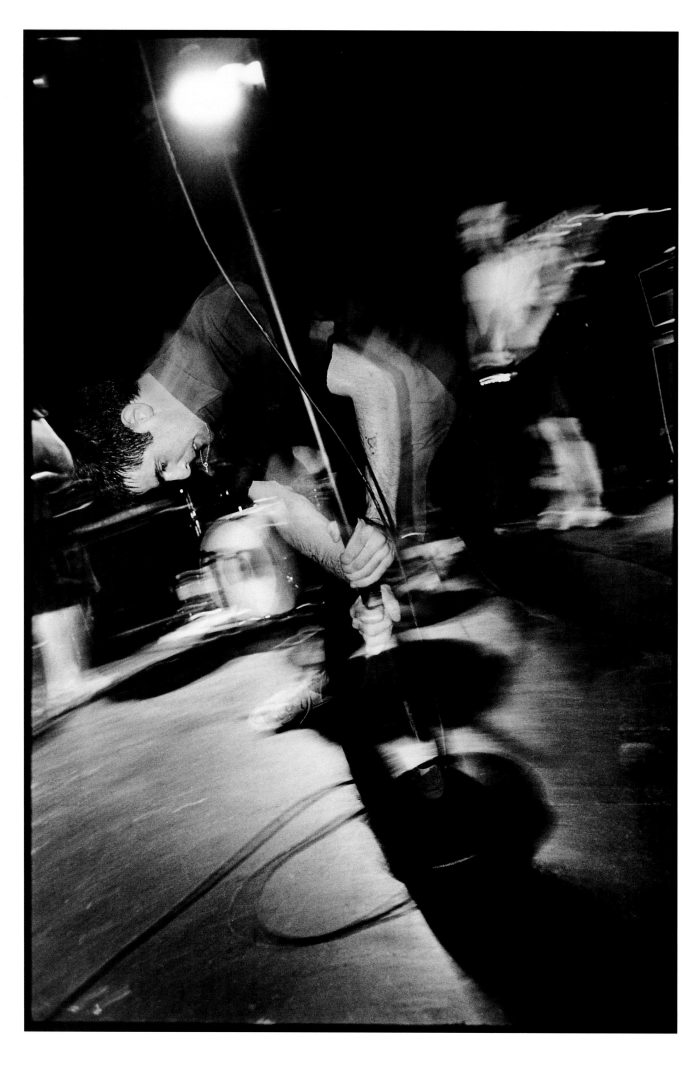

Charles Peterson Fugazi in performance at the International Pop Underground Festival,
Capitol Theater, Olympia, Washington, 1991

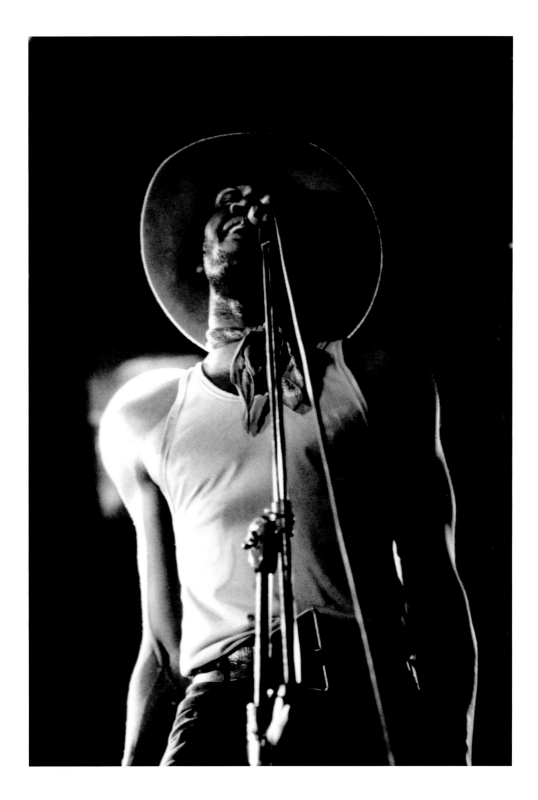

This is my shot of Taj Mahal in performance at the Mariposa Folk Festival in Canada in 1970. Taj lives on the same island I do in Hawaii, and he's a good friend, and—my goodness—what a great performer. Such soul. I think the challenge as a photographer is to be able to soak in and react to the performance and apprehend when a performer is going to hit a peak, or a valley. You really have to make yourself a part of the music to take great music shots. –GN

Graham Nash Taj Mahal in performance
at the Mariposa Folk Festival, Centre Island, Toronto, Canada, 1970

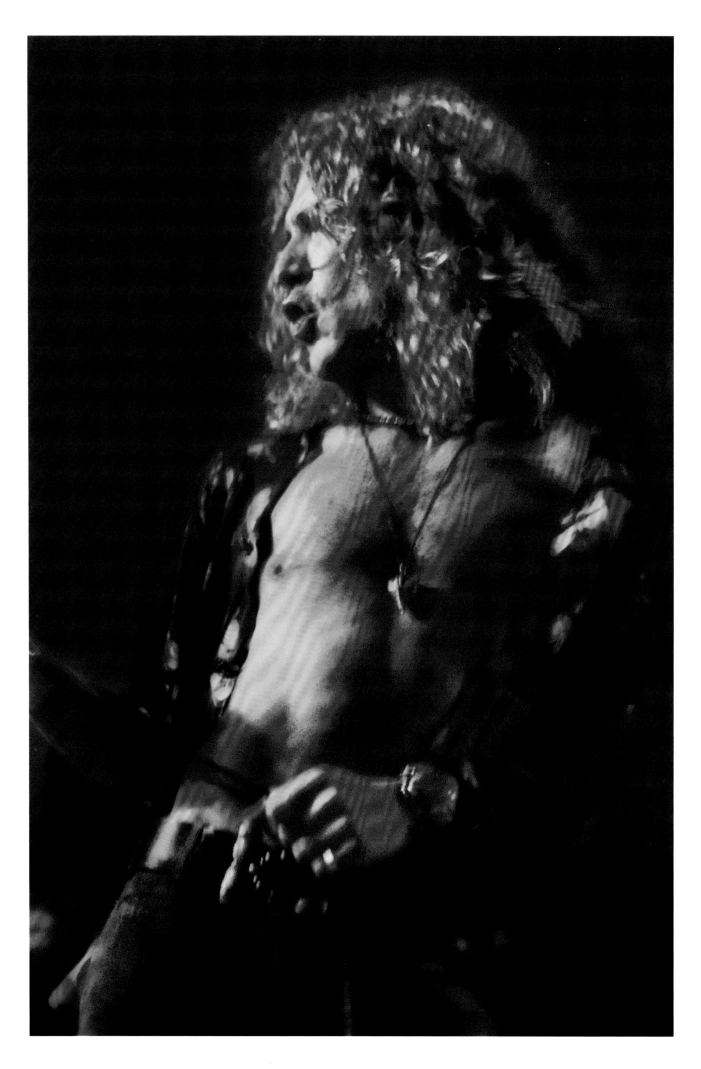

Neal Preston Robert Plant in performance during Led Zeppelin's
North American tour, location unknown, 1975

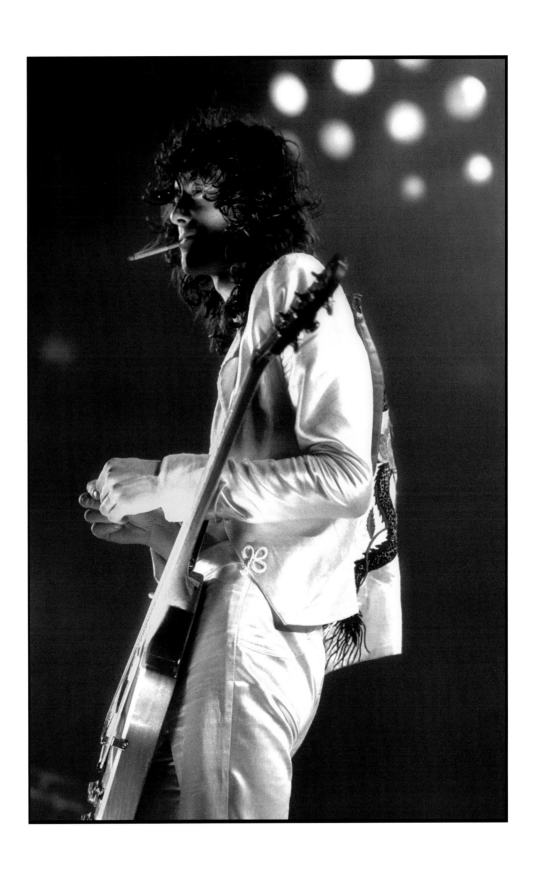

Neal Preston Jimmy Page in performance during
Led Zeppelin's North American tour, Oklahoma City, Oklahoma, 1977

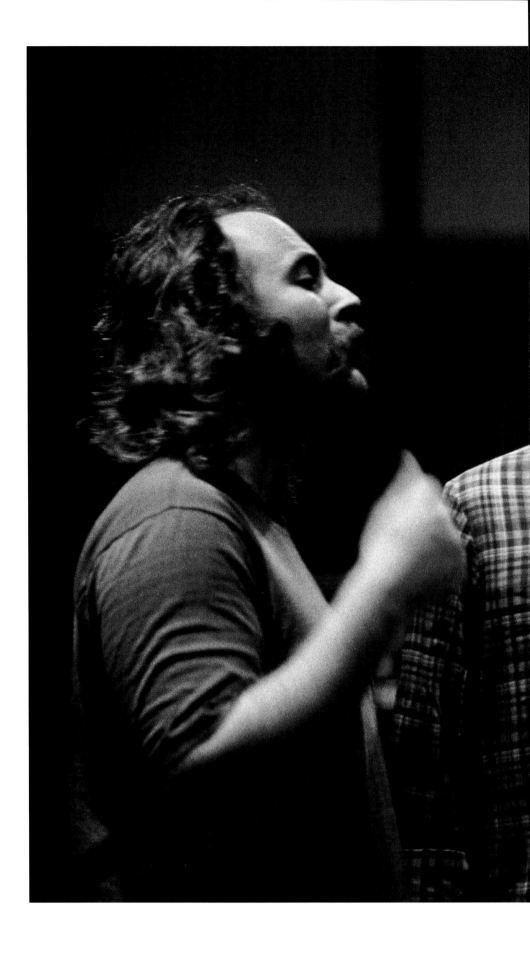

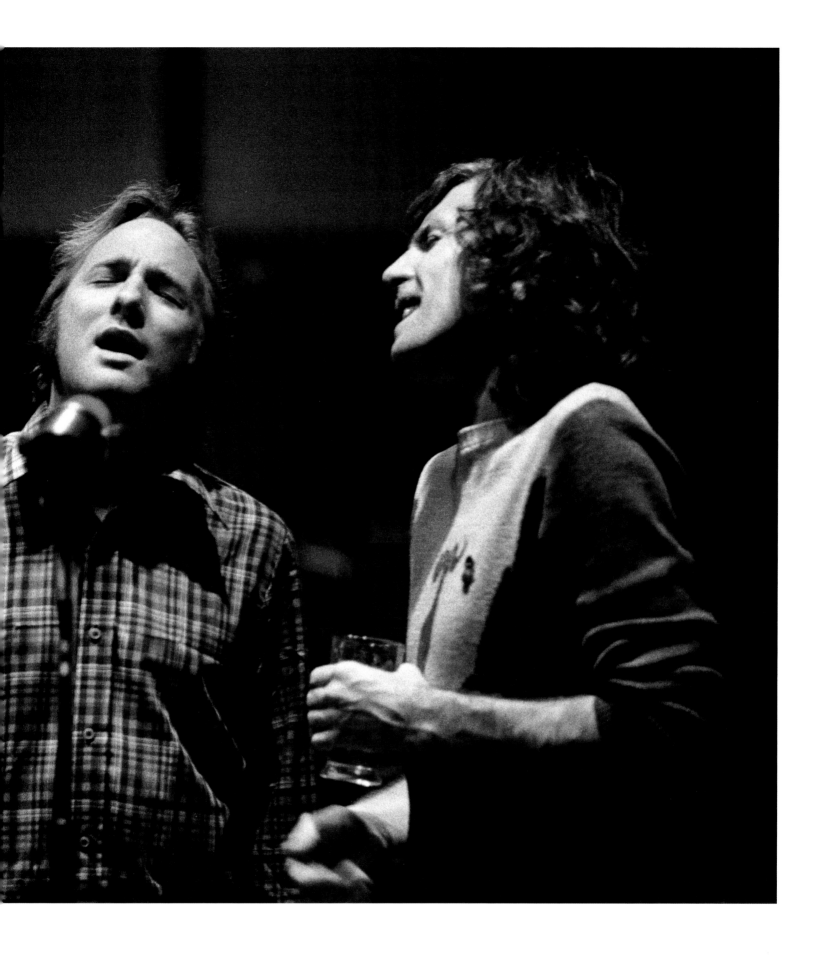

Joel Bernstein David Crosby, Stephen Stills, and Graham Nash
recording their album, *CSN*, at Criteria Studio, Miami, Florida, March 1977

I first became aware of Bob through The Byrds when they did "Mr. Tambourine Man." I should have been more aware of his presence, but unfortunately, I was too busy rocking and rolling myself. One of the first compliments I ever got on my songwriting abilities was from Bob. David Crosby and I were in the penthouse of the Warwick Hotel in New York. Bob was visiting and asked if we had any new tunes. One of my latest was "Southbound Train," and David and I sang it. We got to the end of the song, and I waited with bated breath for Bob to say something. There was a long, long pause. Finally he said, "Sing it again." It was like auditioning for God. –GN

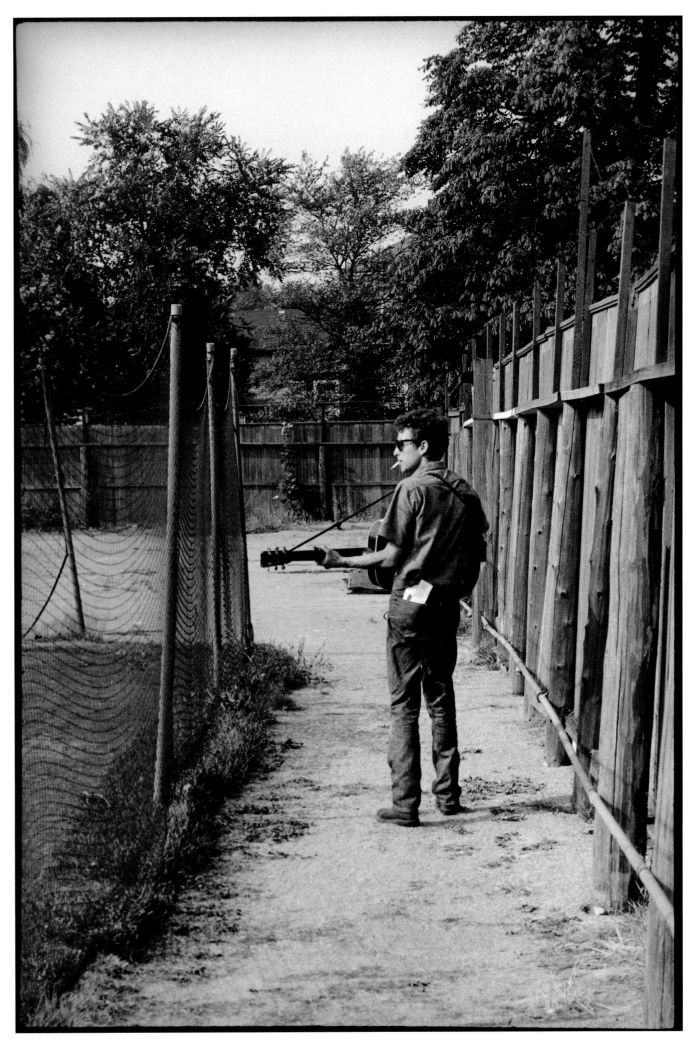

Jim Marshall Bob Dylan waiting to perform
at the Newport Folk Festival, Newport, Rhode Island, July 1963

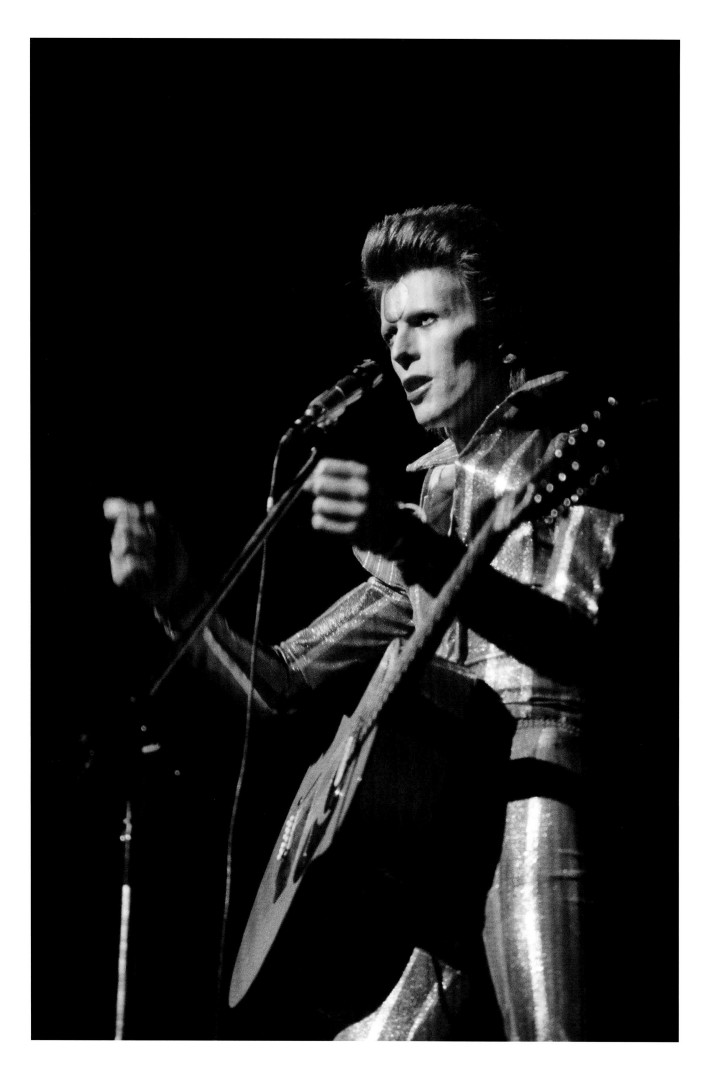

Lynn Goldsmith David Bowie performing
at Radio City Music Hall, New York, New York, February 1973

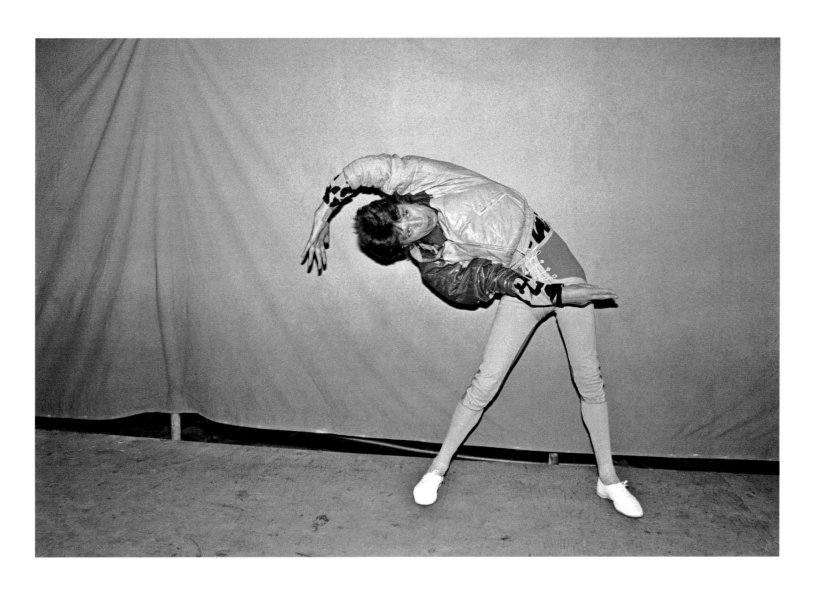

Lynn Goldsmith Mick Jagger warming up backstage
at the Community Center, Tucson, Arizona, July 21, 1978

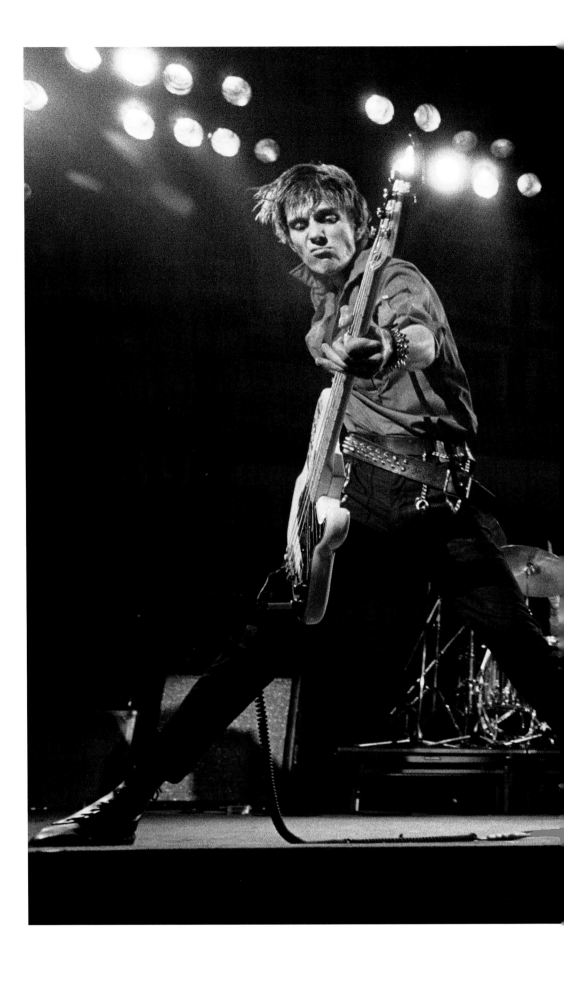

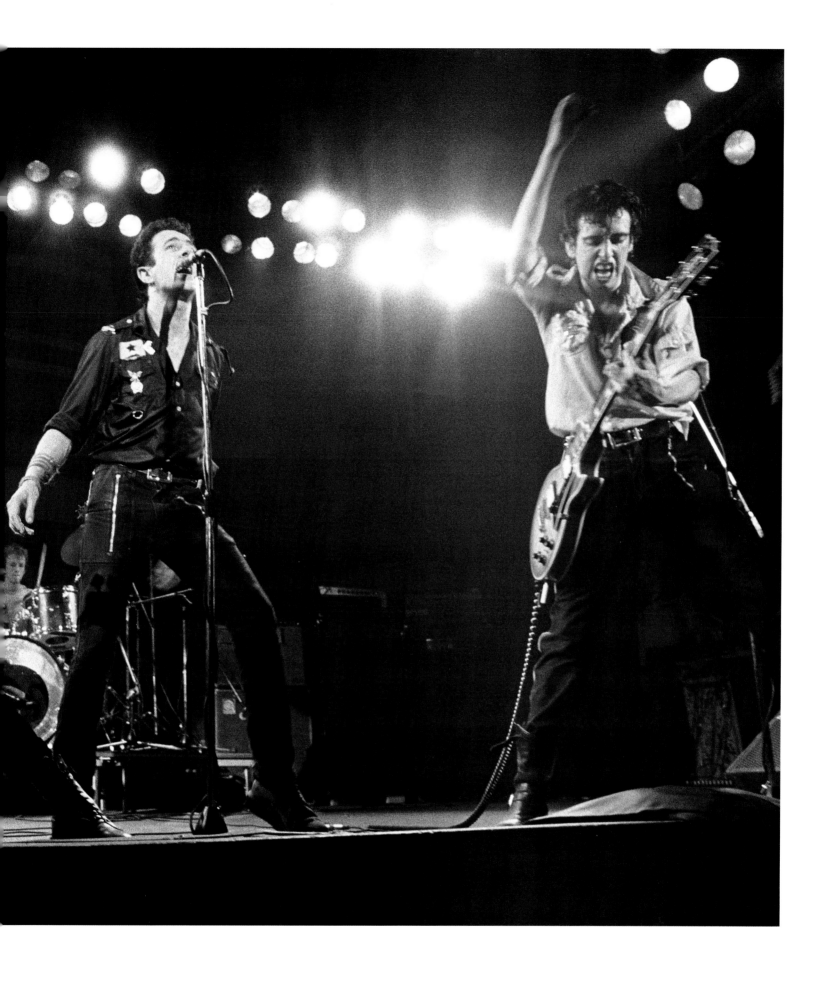

Bob Gruen The Clash in performance at Harvard Square Theatre, Cambridge, Massachusetts, February 16, 1979

Chris Walter Bruce Springsteen and Clarence Clemons in performance
at the Los Angeles Sports Arena, Los Angeles, California, August 20, 1981

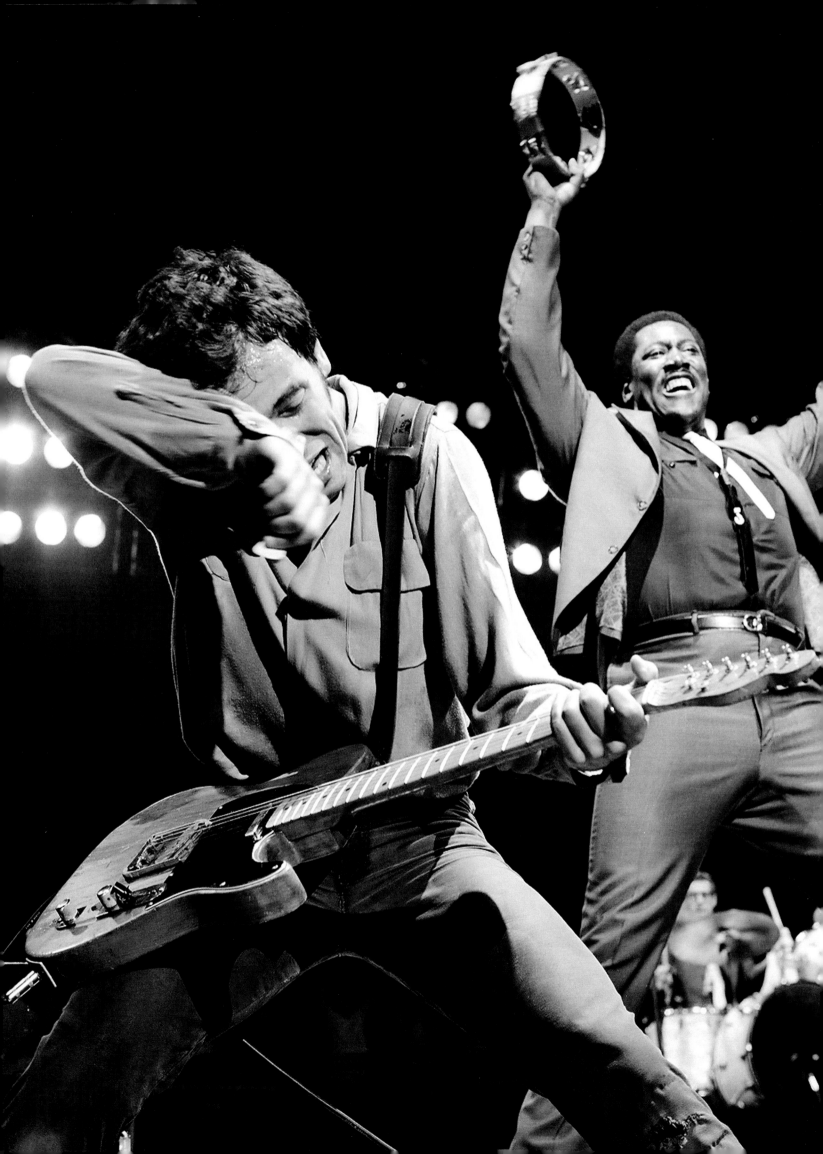

When Johnny Cash went to sing for the prisoners at San Quentin in 1969, he was accompanied by our friend Jim Marshall, who took this fabulous shot. You know how he got this? Jimmy turned around to Johnny and said, "Hey John, you got a word for the warden?" Yeah, I got a word for the warden! –GN

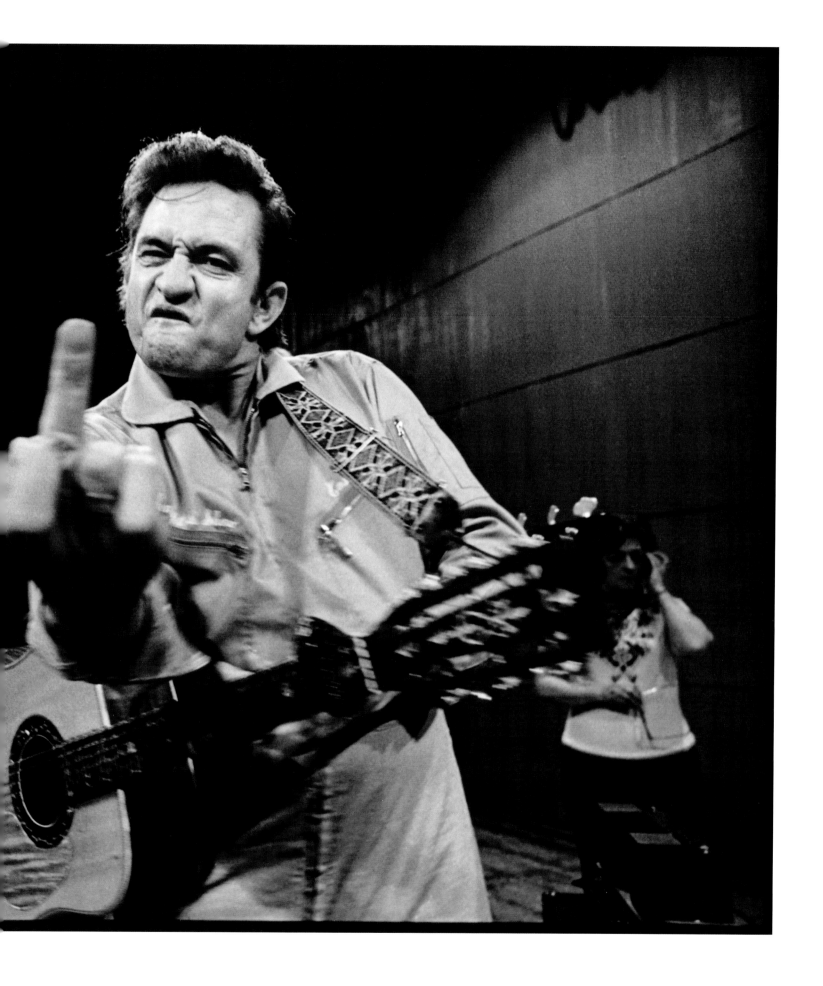

Jim Marshall Johnny Cash flipping the bird at San Quentin Prison, San Quentin, California, 1969

Personal

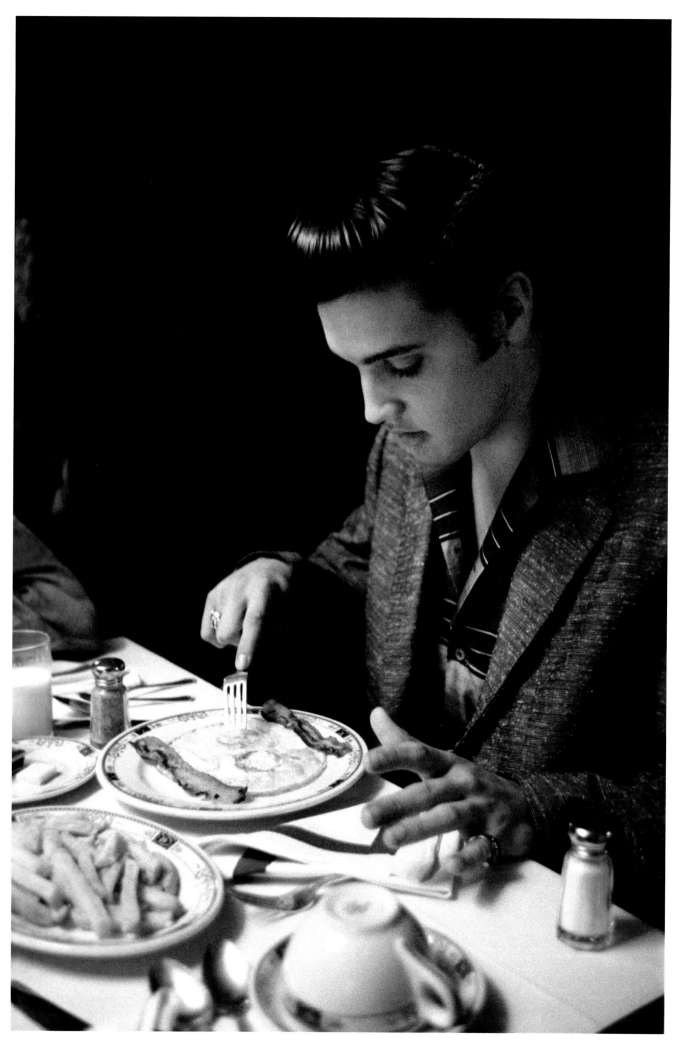

Alfred Wertheimer Elvis Presley eating breakfast at the Jefferson Hotel,
Richmond, Virginia, June 30, 1956

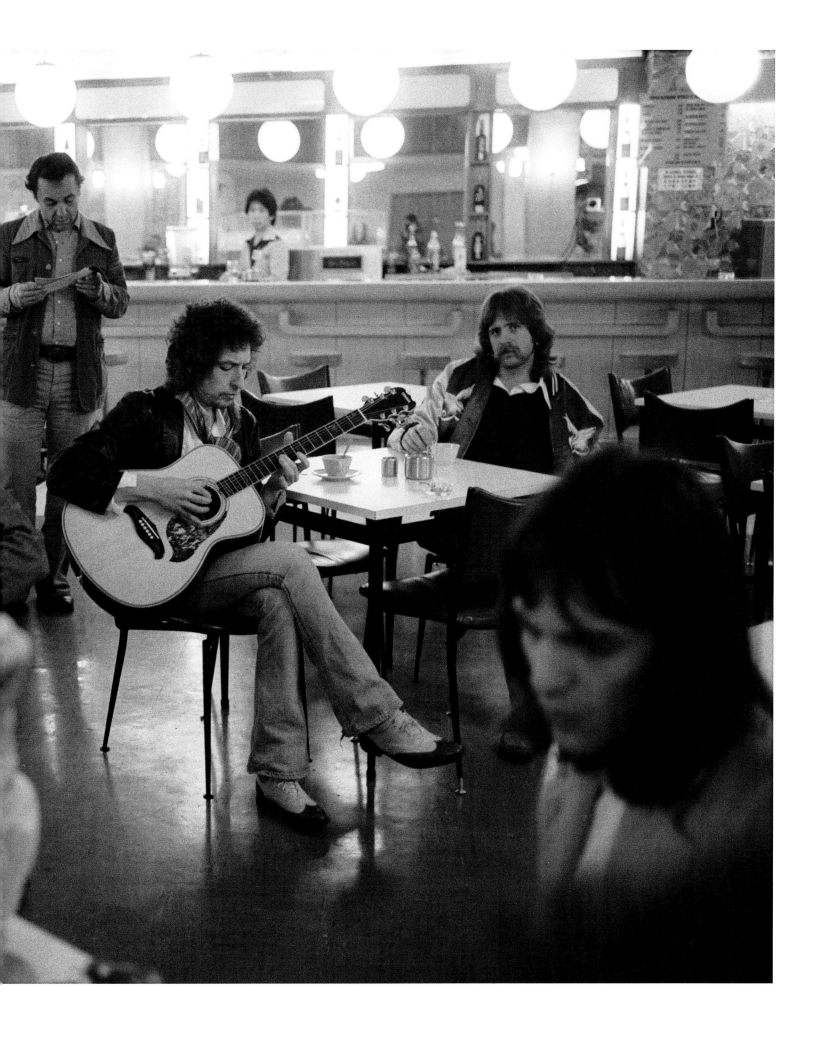

Joel Bernstein Bob Dylan with his tour crew,
Hong Kong International Airport, Hong Kong, March 1978

This is my favorite shot of my dear friend Cass Elliot. She was the one who introduced me to David Crosby and, of course, my life has never been the same since. And David introduced me to Stephen, and they both introduced me to Neil. If Cass hadn't taken me under her wing, I have no idea what would have happened to me, but I believe that Cass was the only one in the world who understood internally, in her mind, what the sound of the three voices of me and David and Stephen would sound like when put together. I'll be forever in her debt. –GN

Henry Diltz Cass Elliot of the Mamas & the Papas, Los Angeles, California, 1968

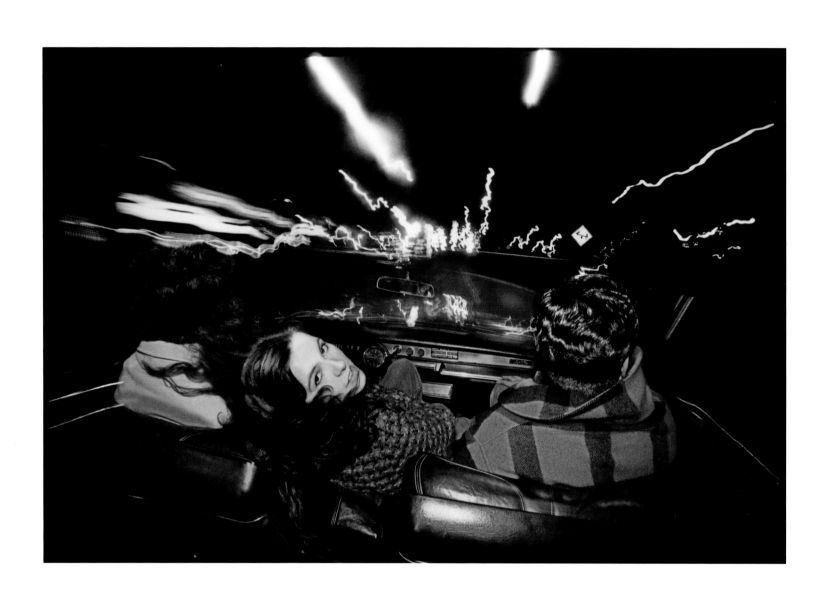

Alice Wheeler *Neko Case and Her Boyfriends,* Tacoma, Washington, February 2000

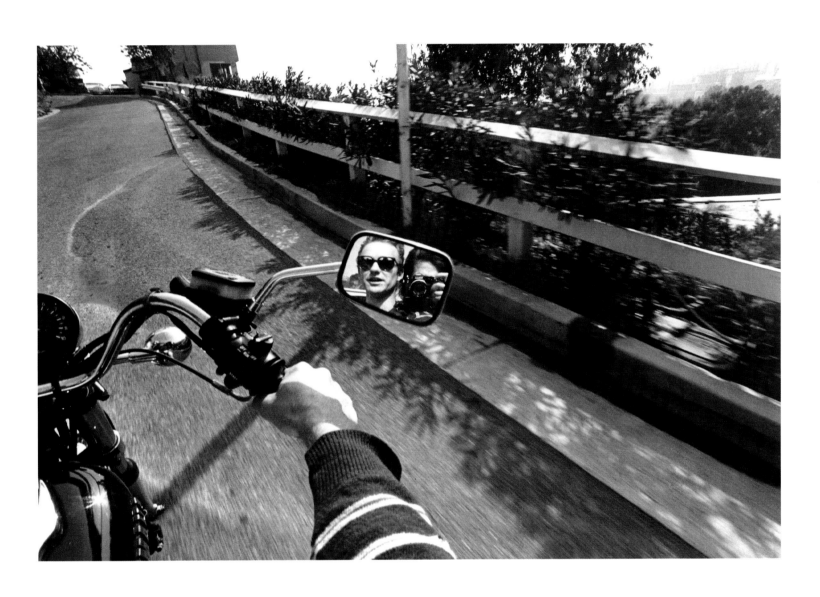

Lynn Goldsmith Sting on a motorcycle with the photographer, Los Angeles, California, 1981

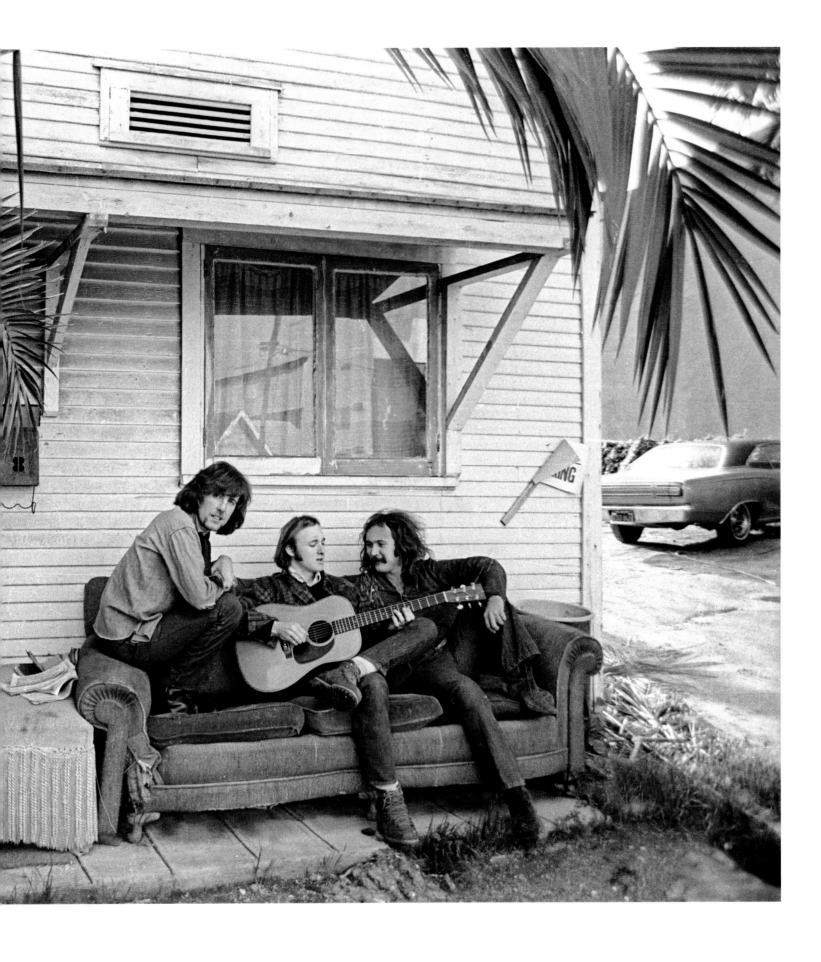

Henry Diltz Graham Nash, Stephen Stills, and David Crosby on
abandoned couch, Los Angeles, California, February 1969
The only alternative to this outtake was used as the jacket
photo for their 1969 debut album, *Crosby, Stills & Nash*

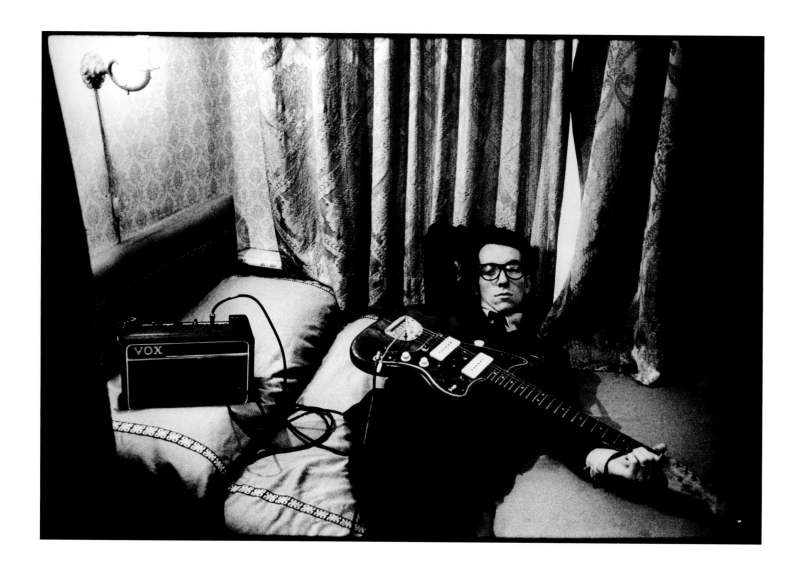

Musicians are well-known for making music anywhere. Look at Elvis here in some kind of train, or tent, or something, makes no difference to him. There, he set up his amp, he's got his guitar. Elvis, he's rockin'. –GN

Anton Corbijn Elvis Costello at his hotel during the *My Aim Is True* tour, Amsterdam, The Netherlands, 1977

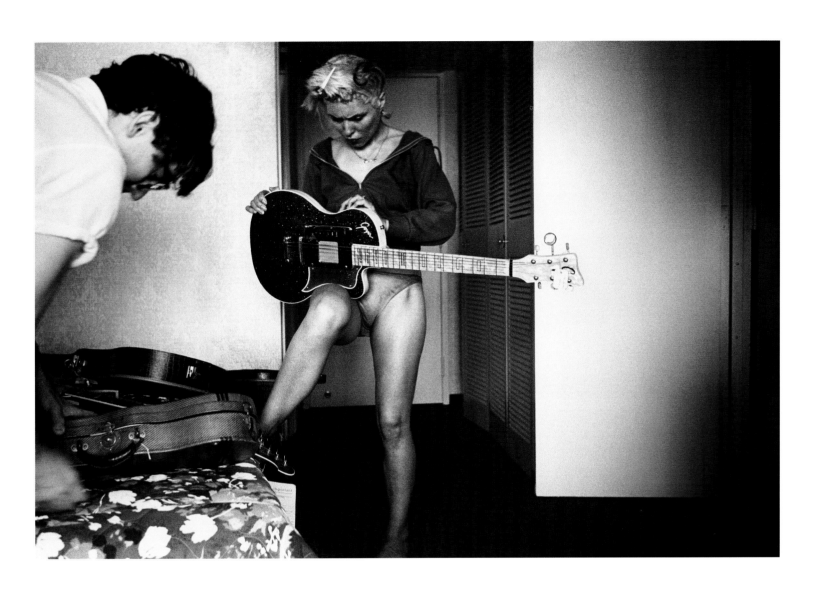

Annie Leibovitz Chris Stein and Debbie Harry
of Blondie, Indianapolis, Indiana, 1979

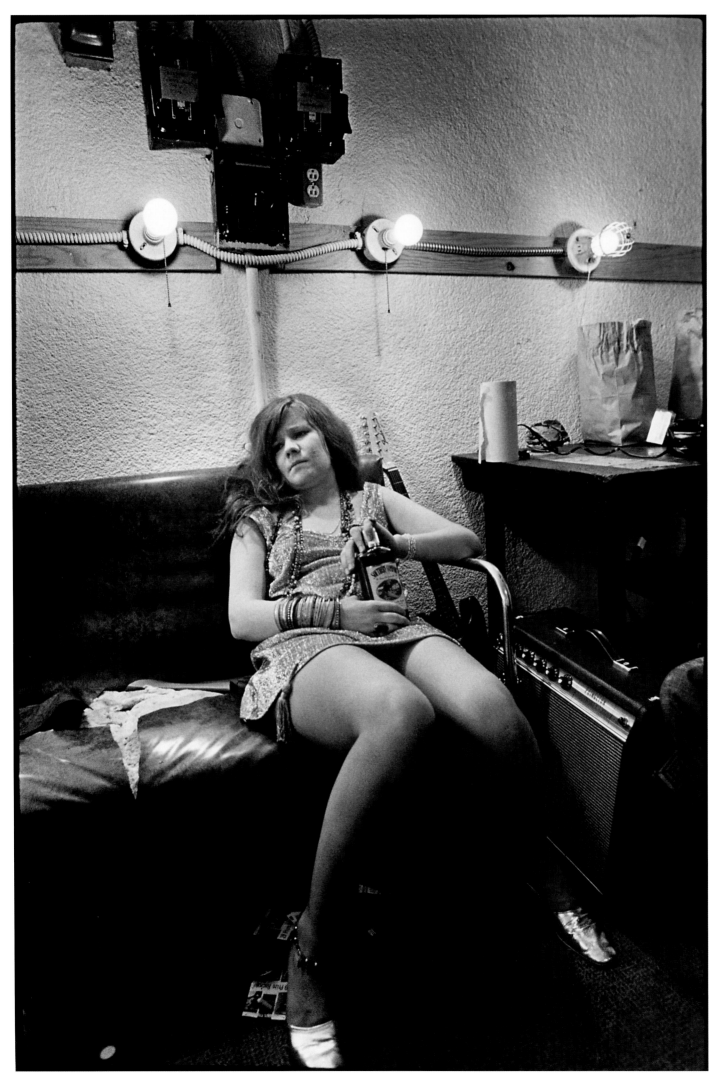

What a private moment. This is Janis Joplin sitting on the couch backstage at Winterland in 1968. People trusted Jim; he was kind of invisible, and that's a good thing for a photographer. You can get many, many great shots when people don't know that you're really taking their image. –GN

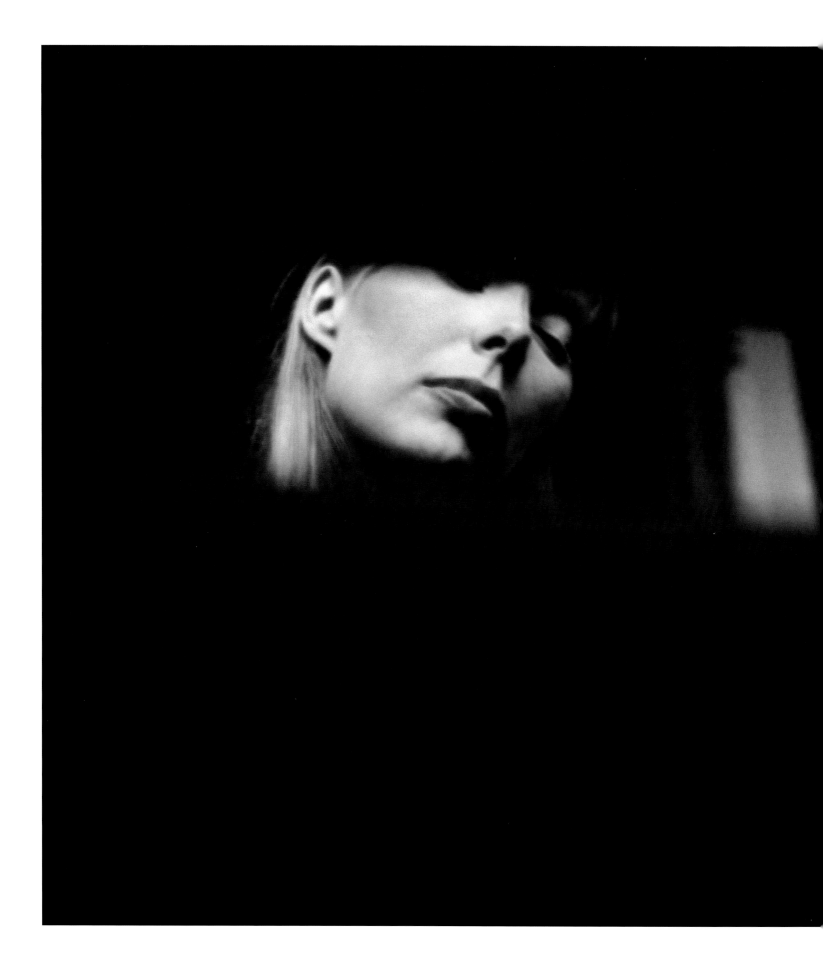

Graham Nash Joni Mitchell listening to music, Laurel Canyon, Los Angeles, California, 1969

I took this shot of Joni Mitchell when she was listening to music. She has her eyes closed; she's in another world. She usually is. It's sometimes difficult taking shots candidly—don't want to intrude— but I think I really got her in this shot. –GN

This fantastic portrait of John Lennon and Yoko Ono was taken by our friend Annie Leibovitz. I believe it was taken very shortly before he was assassinated in 1980. What a tender, tender moment. When I look at this image, I wonder how many great songs John had in his head that we'll never get to hear. –GN

Annie Leibovitz Yoko Ono and John Lennon, New York, New York, December 8, 1980

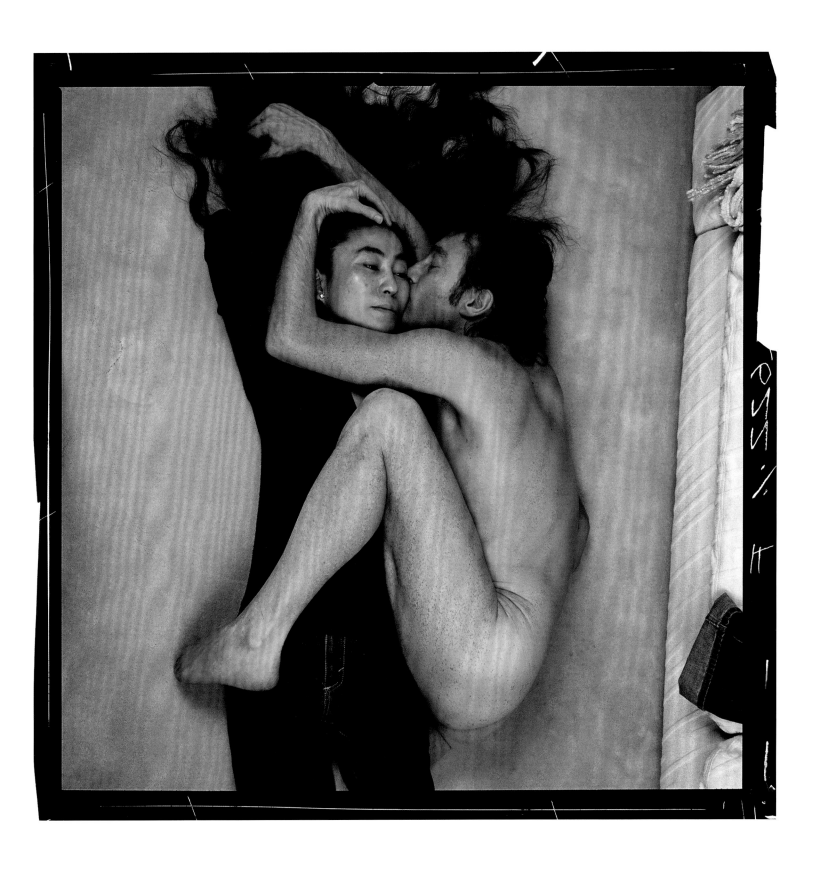

Joel Bernstein Jackson Browne at sound check,
Pine Knob Amphitheatre, Clarkston, Michigan, August 22, 1977

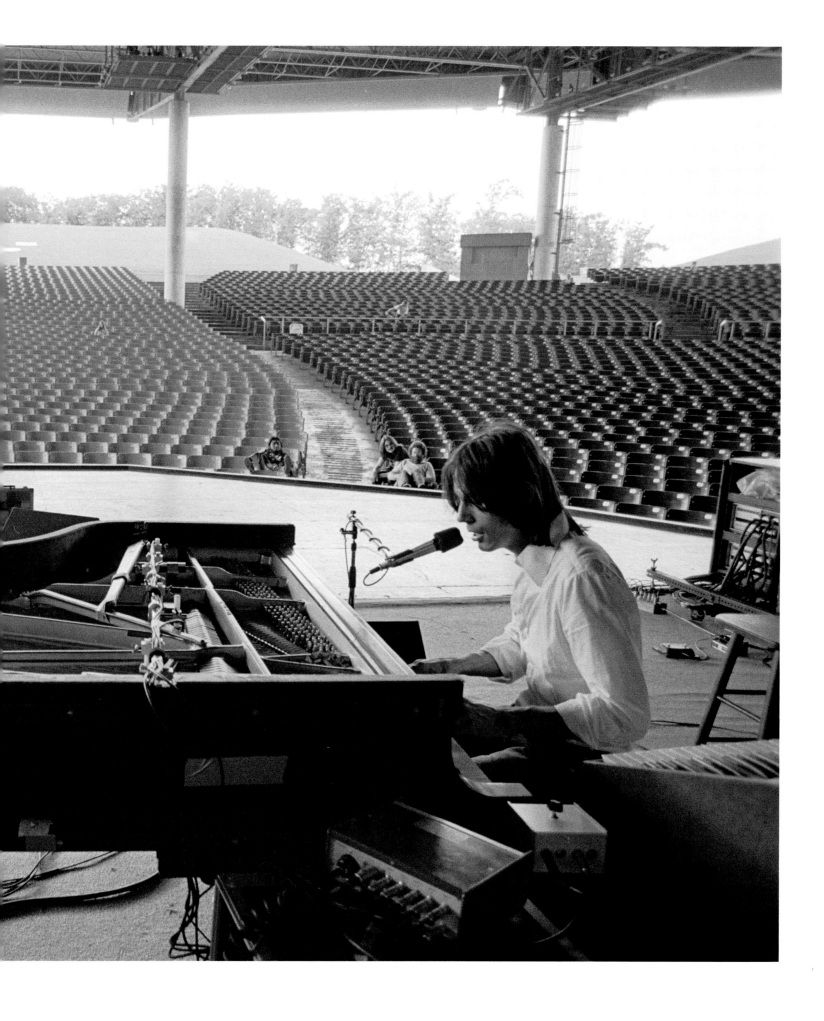

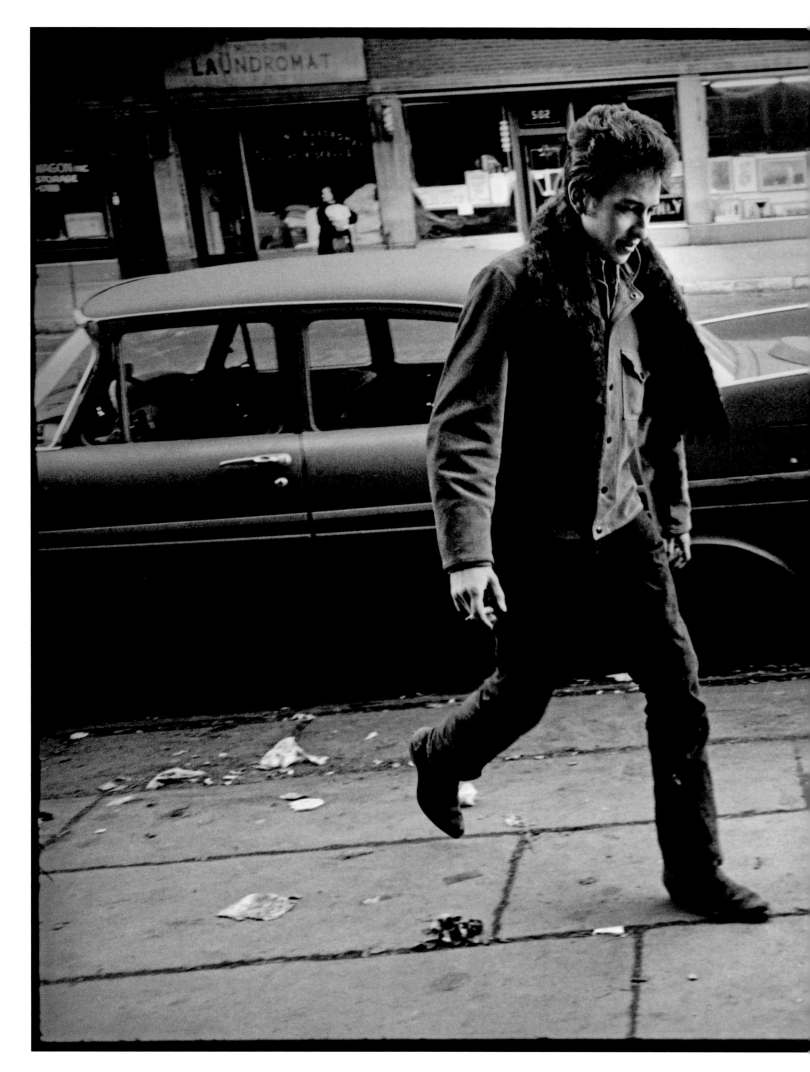

Jim Marshall Bob Dylan kicking tire, New York, New York, 1963

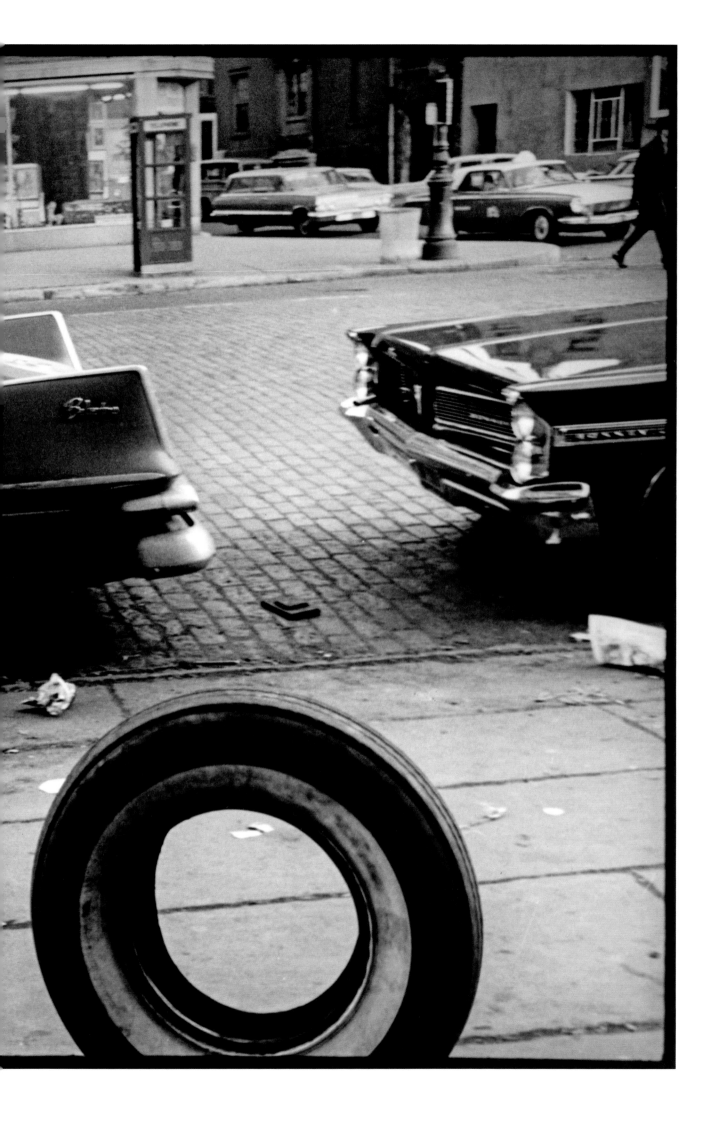

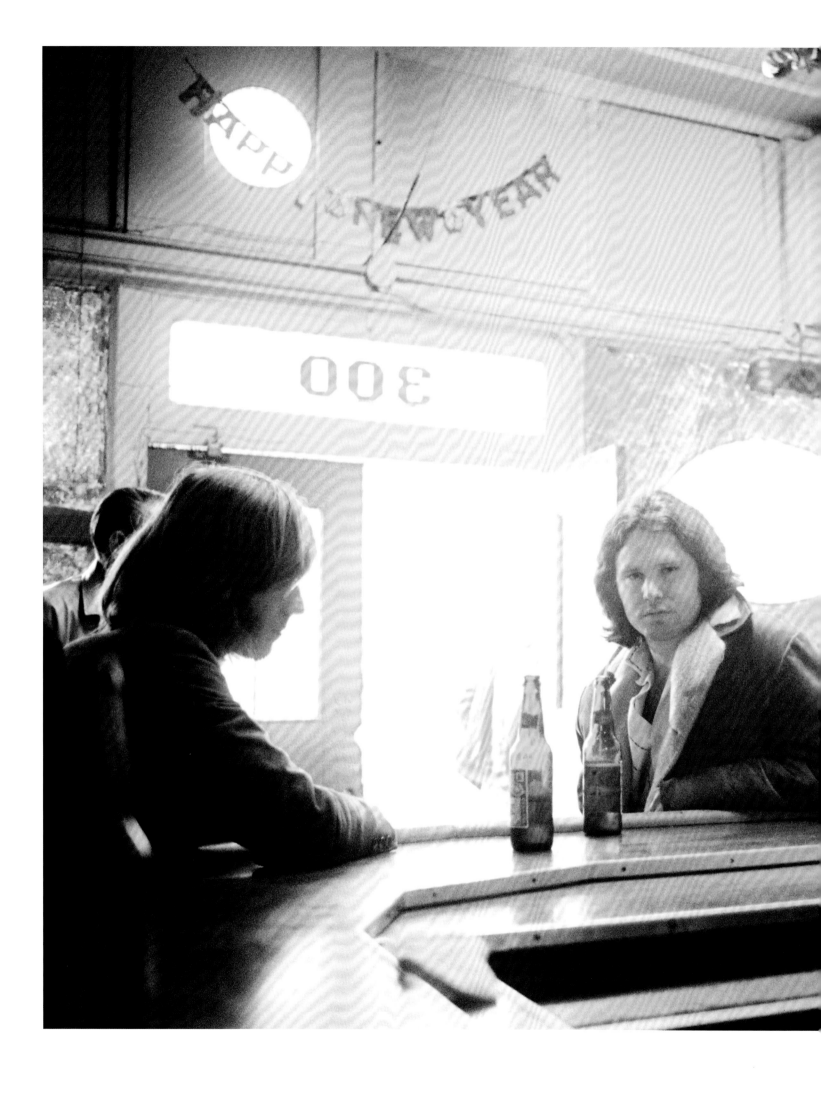

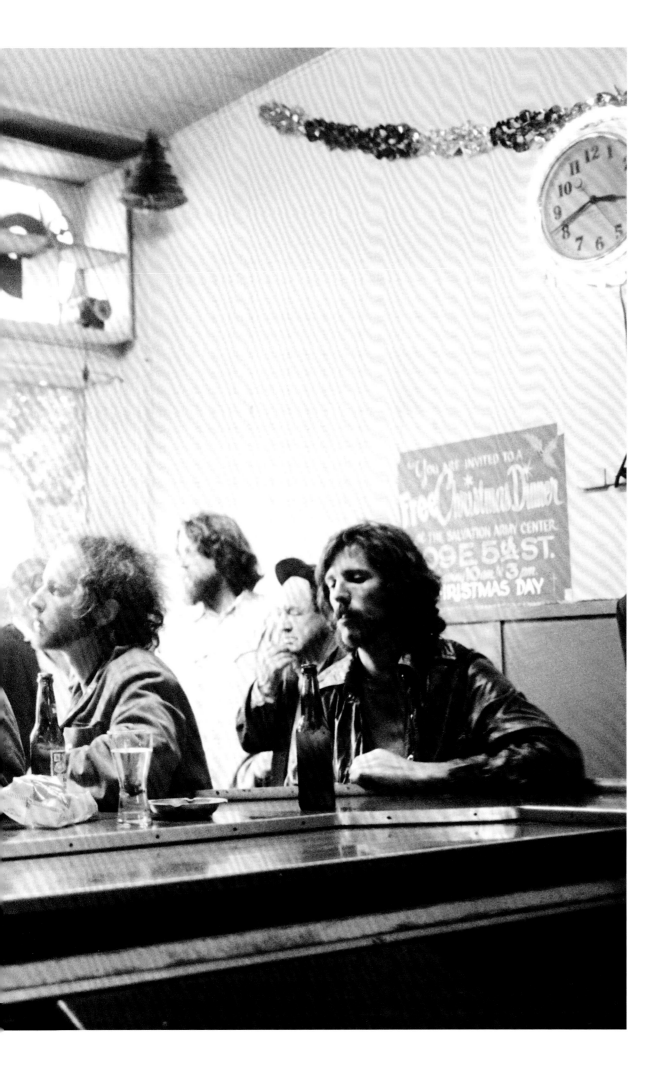

Henry Diltz The Doors—Ray Manzarek, Jim Morrison, Robbie Krieger, and John Densmore—
at the original Hard Rock Café, Los Angeles, California, December 1969

Annie Leibovitz Brian Wilson, Bel-Air, California, 1970

Dennis Hopper Ike and Tina Turner during a photo session
for *River Deep, Mountain High*, Los Angeles, California, 1965

When two cultures collide, great things can sometimes happen. Here's a great, great photograph of Bob Marley. And of course he's smoking the biggest spliff you've ever seen in your life. –GN

Dennis Morris Bob Marley, location unknown, 1975

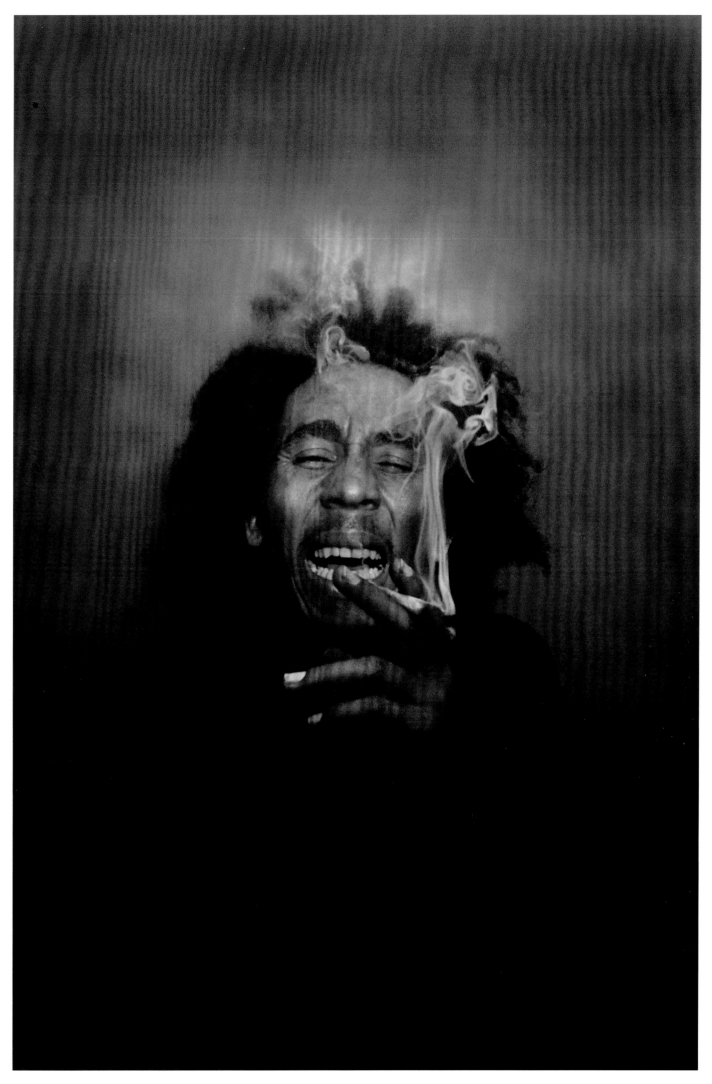

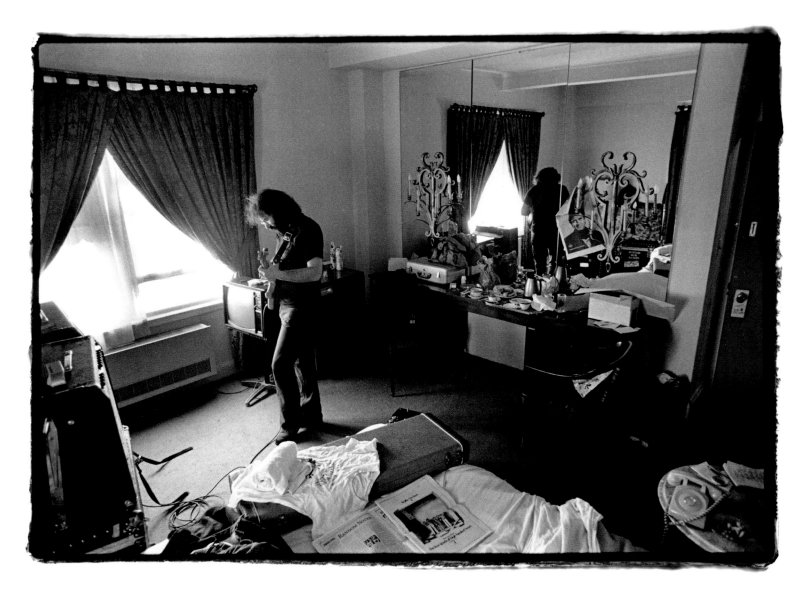

This is my friend Jerry Garcia at the Navarro Hotel in New York City in 1973. Spaced. Doesn't even see what's around him. He's just waiting for the next note. It's always strange being in a different hotel each night. One of the worst things you can do is try to put last night's key into tonight's hotel door. Happened to me many times. —GN

Annie Leibovitz Jerry Garcia at the Navarro Hotel, New York, New York, 1973

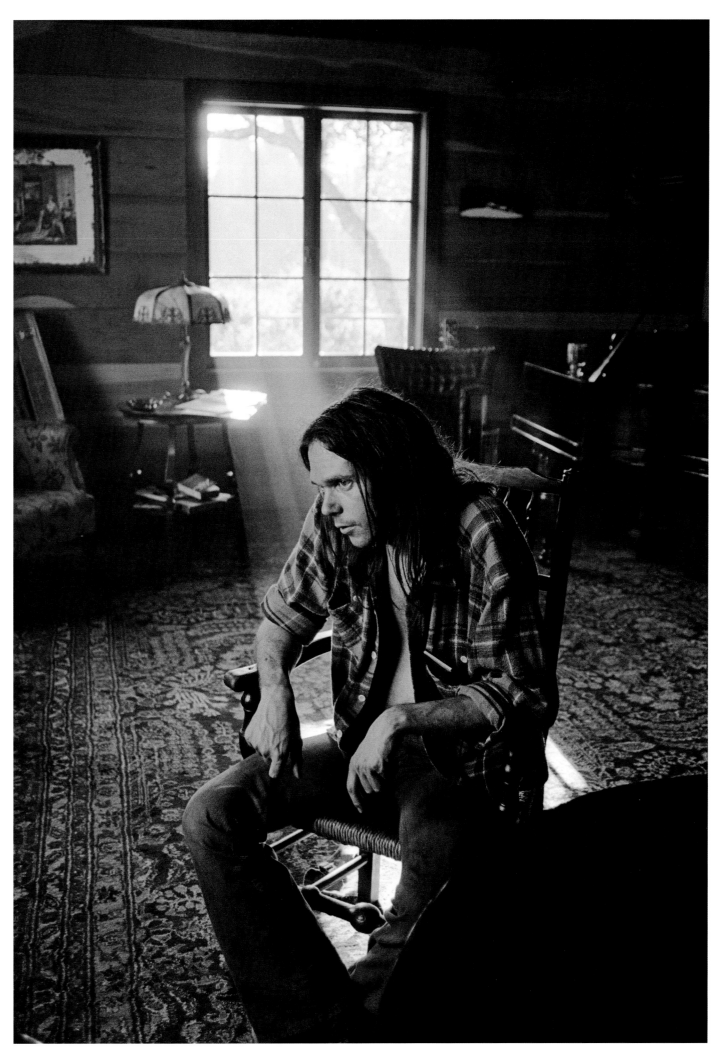

Joel Bernstein Neil Young at home near Woodside, California, September 1971

I used to be in a band called The Hollies in England in the early sixties—we named ourselves after Buddy Holly. We were great lovers of his music. It was incredibly simple. Buddy was one of us. He didn't look like the normal rock star. He wore glasses. He was cool. This is a shot of Buddy taken on the band bus in late 1958. It must have been close to the day that, unfortunately, he was killed along with Ritchie Valens and the Big Bopper after they played at the Surf Ballroom in Clear Lake, Iowa, on February 2, 1959. He was killed very early in the morning of February 3rd, a tragic day for me. I'd lost a friend. —GN

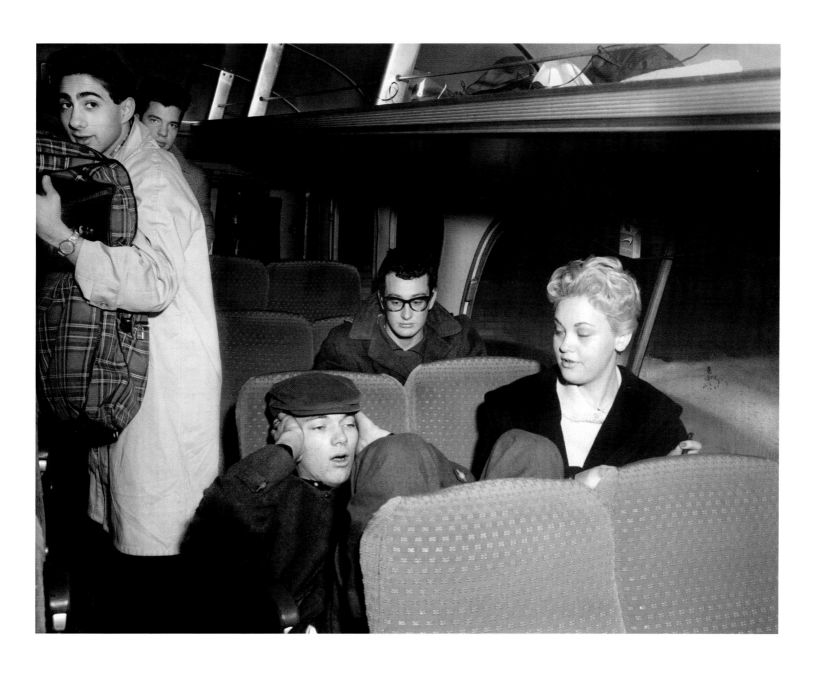

Lew Allen Buddy Holly on a tour bus with drummer Jerry Allison and singer Judith Shepard seated in front of him and Frank Maffei of Danny and the Juniors standing in the aisle, Rochester, New York, circa 1958

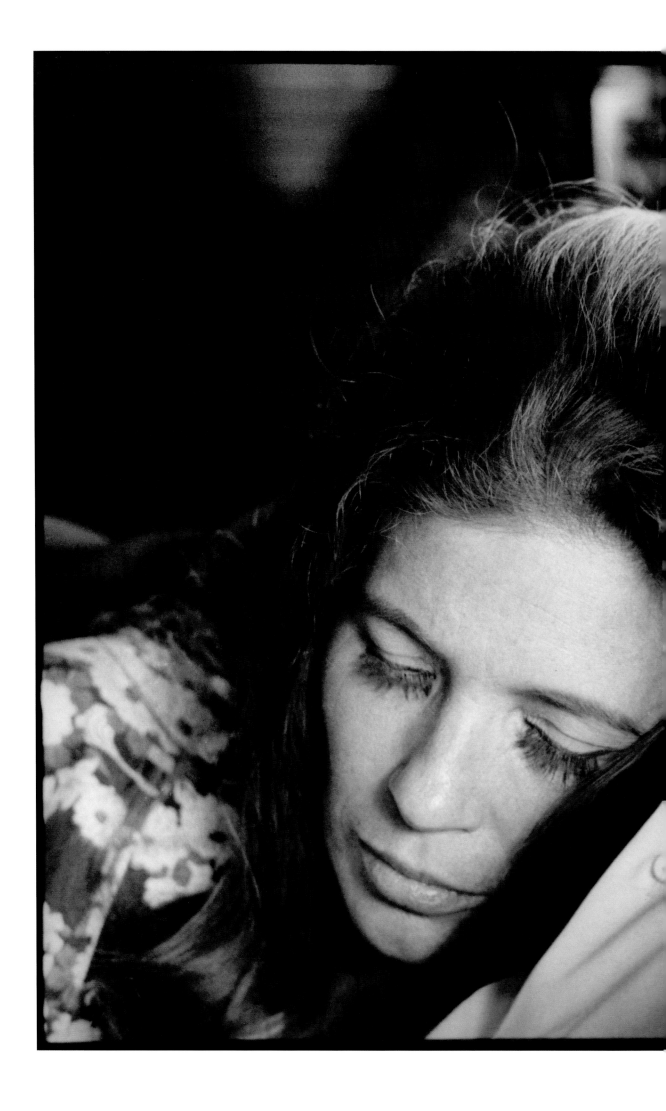

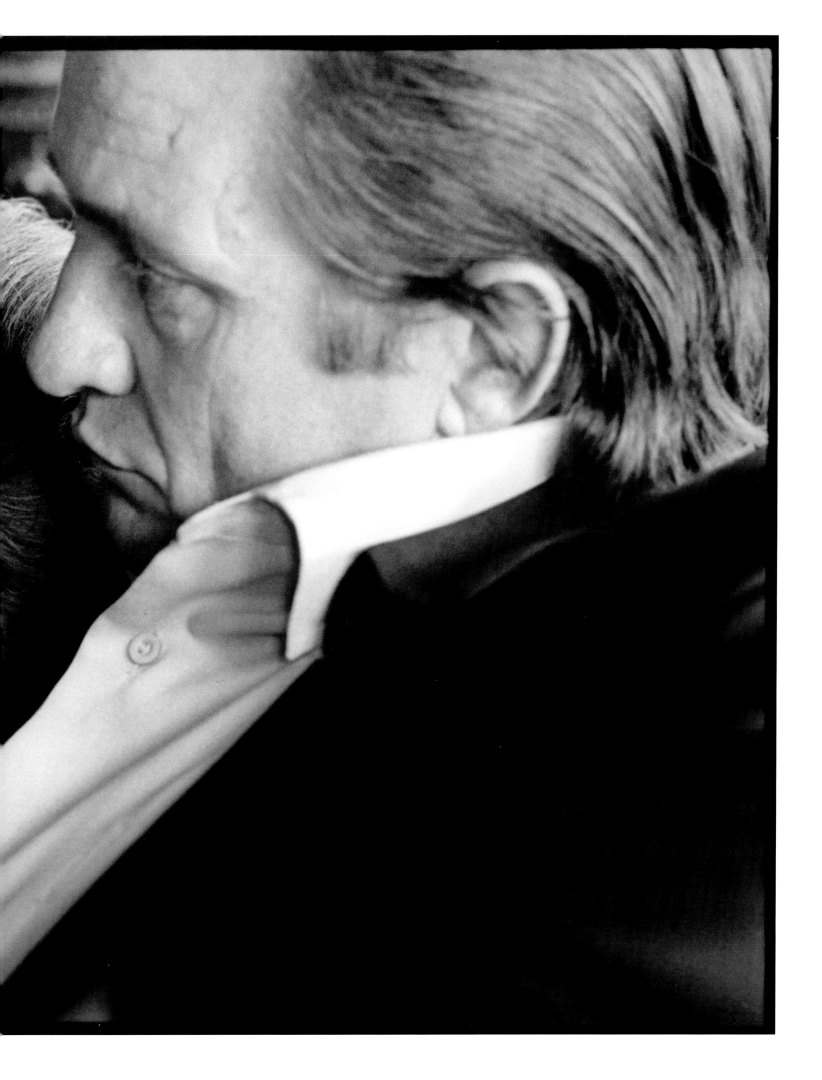

Jim Marshall June Carter and Johnny Cash listening to music, Hendersonville, Tennessee, 1969

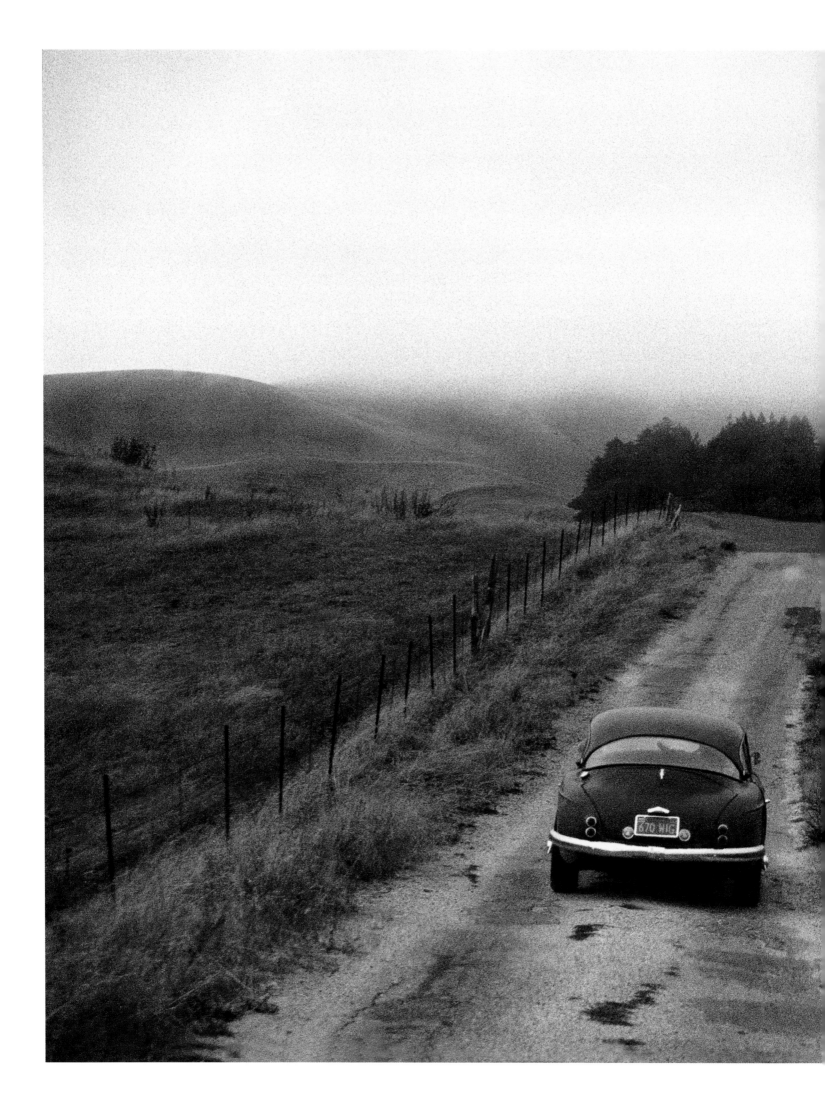

Graham Nash Neil Young driving home to Broken Arrow Ranch after a performance
by Crosby, Stills, Nash & Young, Northern California, 1988

Every Picture Tells a Thousand Stories

AFTERWORD BY
JASEN EMMONS

Never try to meet your rock 'n' roll heroes. I realize the temptation is powerful, the potential encounter so rich with possibilities that even thinking of it makes your hands tremble. You may have imagined all of the things you've wanted to say to your favorite artist ("musician" doesn't begin to cover it): what her music has meant to your existence, the ways it has shaped you, pulled you through the rough times and helped you celebrate when you're on top of the world. You may have even pictured yourself backstage in the dressing room or on the tour bus, where the artist immediately senses that you understand her work at a deeper level than anyone else she's ever met. She takes both your hands in hers, leans close and says something you'll never forget. Your life is now complete.

Which could happen, I guess.

But let me offer an alternative, more likely version that I heard years ago when friends of mine came to dinner with their two young nieces. The older girl, Shelly, a fifteen-year-old redhead, had scrawled "PUSA" in black ink on the pale underside of her forearm, and after we finished eating, I asked about it. Her aunt explained that earlier in the day she'd driven Shelly, an aspiring drummer, from West Seattle to Tower Records at the base of Queen Anne Hill so she could meet her rock 'n' roll heroes, The Presidents of the United States of America (PUSA). PUSA was releasing a new CD and

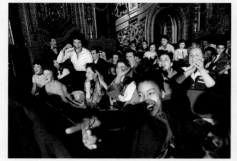

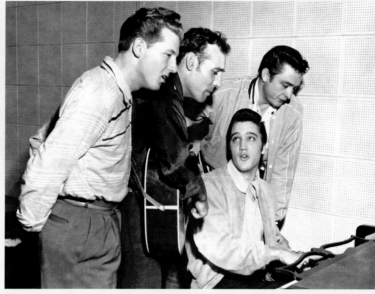

left **Walter Sanders** Audience members enjoy Alan Freed's rock 'n' roll show
at the Paramount Theater, Brooklyn, New York, January 1, 1955

right **Photographer unknown** The Million Dollar Quartet—Jerry Lee Lewis, Carl Perkins, Elvis
Presley, and Johnny Cash—in Sun Studios, Memphis, Tennessee, December 4, 1956

signing copies for true believers. Shelly stood in line dutifully, anticipating her moment
with her personal legends, rehearsing what she would say. Afterward, as they returned
to West Seattle, her aunt asked Shelly if she'd spoken to the band. "I'd like to think I did,"
Shelly said.

I'd like to think I did?

How perfect. Who hasn't had the same out-of-body experience when we were
face-to-face with someone we'd always wanted to meet? Who hasn't been speechless
with disbelief and happiness then spent the next hour, the next day, the next *week*,
thinking of all the things we would have said if we'd been able to form words?

OK, so most of us will never experience an encounter with the royalty of rock.
But what if I still need to dream of it? you ask. What if I need more than the music—the
beloved vinyl, the alphabetized CDs and DVDs, the gigabytes of digital downloads? What
if even the front-row concert seat doesn't cut it anymore? What if that's not enough to
feed the consistent hunger you feel to get just a little bit closer to your favorite artist?

Then turn to something that is always available, that will never let you down:
the photographs.

For any serious music fan, the images of our rock 'n' roll luminaries are almost
as important to us as their music. Depending on our age and the depths of our devo-
tion, we tack their posters to our walls, tape their pictures to our lockers and computer
monitors, stick their visage on our bumpers, bear their faces on our T-shirts. It's through
the images—on album covers, in magazines, in books like the one you're holding—that
we connect with them in ways that would never be possible in real life.

The photographs may document historic moments that we missed, like one of
Alan Freed's rock 'n' roll shows at the ornate Paramount Theater in Brooklyn, with joyous
kids leaping out of their seats, or the only time that Sun Records' biggest stars—the
million-dollar quartet of Elvis Presley, Carl Perkins, Johnny Cash, and Jerry Lee Lewis—
were in a studio together. The photographs may capture a performance that almost
everyone missed, like Jim Marshall's shot of an ecstatic Jimi Hendrix playing to an empty

arena at a sound check for the Monterey Pop Festival in 1967, eyes squeezed tight, left arm thrown back as if by the power of his Stratocaster (p. 2). Thanks to Marshall's photograph, you can not only feel like you were standing in front of the stage, but examine the little details you'd never see even if you had been there, like the fur trim on Hendrix's Royal Hussar's jacket and the regal lion on his medallion.

It's through the images that we can chart the distances an artist has traveled, and note the changing times and personas. Take Jürgen Vollmer's black-and-white shot of John Lennon leaning against a doorway in the bleak port district of Hamburg, Germany (p. 55). Three other members of The Beatles—Paul McCartney, George Harrison, and Stu Sutcliffe—pass by in their pointy leather boots. It's 1961. The Beatles are leather-clad rockers with slicked-back hair, toiling ten hours a day at the Top Ten Club, honing their skills and dreaming of something far better and bigger. They have not yet met their future manager Brian Epstein, who will insisit on putting them in tailored, matching suits. In Vollmer's photograph, they resemble a tight-knit gang, with Lennon as their leader, and no one would blame you for crossing the street to avoid them. Now compare that image with Richard Avedon's psychedelic portraits of The Beatles (p. 50), taken six years later, in 1967, when they can't walk down a street without being mobbed, and they no longer play live shows or just want to hold your hand. Now they want to turn you on and take you across the universe.

Look at Jim Marshall's two shots of Bob Dylan, circa 1963: waiting offstage to perform at a workshop at the Newport Folk Festival (p. 105) and walking the streets of New York City (p. 134). In his jeans and work boots, Dylan embodies the working-class fashion and spirit of his hero, Woody Guthrie. Next, look at Daniel Kramer's picture of Dylan taken two years later, in 1965, as he performs with Joan Baez in New Haven, Connecticut (p. 64). With his cocked right leg, Dylan looks like a rocker, while Baez, the Queen of Folk who had introduced "Bobby" to her legion of fans, sits to one side with bowed reverence. It's all over now, baby blue. Finally, compare those images with Barry Feinstein's photograph from the grueling 1966 world tour with The Hawks, when Dylan became a certified rock star. Wearing a herringbone suit, an electric-haired Dylan signs a poster of himself as a fresh-faced folkie that, taken only a year earlier, looks like a portrait from a distant era (p. 80).

The photographs also provide access. They get us past security to the anonymous hotel rooms and dingy dressing rooms where the artist waits, prepares, recovers. None of them are places you'd want to spend any length of time. For musicians, they're places to kill time, like Joel Bernstein's shot of Neil Young and his wife, Susan Acevedo, backstage at the Electric Factory in Philadelphia (opposite). Young is surrounded by guitars and battered cases, lost in thought, waiting to be summoned to the stage. Or take Elliott Landy's photograph of Levon Helm, singer and drummer for The Band (p. 63). He sits smoking before a performance at the Fillmore East in New York City, indifferent to the galvanized steel tub of iced canned beer at his feet. With his black hat, scraggly beard and cowboy boots, Helm resembles a Confederate officer enjoying a final cigarette before battle. In a moment, it seems, he'll rise from the chair and walk outside to rally his troops. The truth is, there is nothing romantic about these moments. What you take away from most of them is a sense of isolation and loneliness, like

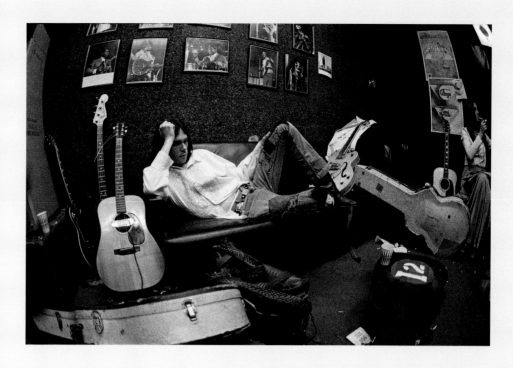

Joel Bernstein Neil Young and his wife, Susan Acevedo, backstage
at the Electric Factory before a performance with Crazy Horse,
Philadelphia, Pennsylvania, February 28, 1970

Janis Joplin slouched down on a vinyl couch at San Francisco's Winterland, cradling a fifth of Southern Comfort in her lap. The light bulbs are naked, the seat cushion ruptured, her face turned away from the camera as if her surroundings—her *life*—are almost more than she can bear (p. 126). Even Mick Jagger, in Lynn Goldsmith's shot of him stretching backstage before a performance, looks too small and frail to command the attention of a stadium filled with demanding fans (p. 107).

When it's showtime, they come alive—onstage and in the photographs—in ways that seem hard to fathom when you've just witnessed them in the dressing room. Rod Stewart rushes onto the stage during The Faces' final show in Montreal, looking so eager to perform that he floats above the floor. Tina Turner thrashes beneath the strobe lights at the Honkamonka Room in Queens as if exorcising the Devil. The artists never tire or disappoint. The Clash never lose their fury, Robert Plant never loses his swagger, Pete Townshend never descends from his leap. We can view them at their prime, again and again, reliving moments for eternity that actually passed us by in the blink of an eye.

Of course, like the rest of us, musicians do age, and they do succumb. The photographs document the casualties and the survivors. They allow us to reflect on their fates, and dream up better ones. Who can look at the shot of a forlorn-looking Buddy Holly sitting on another bus without thinking that if he hadn't abandoned his frozen, faulty tour bus in Mason City, Iowa for a chartered single-engine plane, he might still be with us, along with Ritchie Valens and the Big Bopper (p. 147)? Or stare at Kurt Cobain as he sprawls into Chad Channing's drum kit and wonder what it would have taken to halt his tragic freefall (p. 85)?

Savor the pictures. Linger over the details. Through them we can create our own stories and mythologies about our rock 'n' roll heroes. We can decide for ourselves what they were thinking or feeling in these suspended moments. And imagine what we would have said if we'd been there with them.

Acknowledgments

Michael Jensen and Jasen Emmons together created this opportunity for me to develop a show and book about two of my favorite subjects, photography and music, and I am grateful to them for this. Though the images shown here were chosen by me, I had great help from Jasen, Michelle Dunn Marsh, and the curatorial advisory committee of Deborah Klochko, Executive Director of the Museum of Photographic Arts in San Diego; Christian Peterson, Associate Curator, Department of Photographs at the Minneapolis Institute of Arts; and Sylvia Wolf, Director of the Henry Art Gallery in Seattle.

My friend, the photographer Lisa Law, provided the title *Taking Aim,* and I am grateful.

I'd like to personally thank Paul Allen for his vision in creating EMP, as well as Josi Callan, Christina Orr-Cahall, and the staff at EMP for bringing this project to fruition. Marita Holdaway of Benham Gallery, who represents my photography, is always a powerful force in moving things forward in the Seattle art community, and I appreciate her support. Thank you to the people of the city of Seattle for their unwavering interest in the arts.

My longtime friend and business partner Mac Holbert continues to set industry standards for extraordinary pigment printing through Nash Editions, and I am thankful for his ongoing support, including the work he's done on prints for this exhibition.

My family remains my foundation and joy—my wife Susan, and my beautiful children Jackson, Will, and Nile.

—Graham Nash

It's been my experience that every exhibition is a unique blend of collaboration and serendipity, and this one was no exception. Working with Graham Nash has been a great pleasure, and throughout the process, I was continually impressed by how engaged he was with the project and the world at large, and how open he was to feedback. His involvement came about thanks to Michael Jensen, who introduced me to Graham and helped foster our relationship as we wrestled with the original concept.

Early on, Graham suggested creating an advisory board of renowned photography curators, and Deborah Klochko, Christian Peterson, and Sylvia Wolf (whom Graham knew when she was a curator at the Whitney Museum of Art) were extremely generous with their time, expertise, and enthusiasm. They helped whittle down the initial pool of images to a more manageable size and offered excellent suggestions on how to conceptually frame the final selections.

In June 2008, I happened to meet Michelle Dunn Marsh on Graham's tour bus after Crosby Stills & Nash played at the Chateau St. Michelle Winery in Woodinville, Washington, on a damp, chilly night. She and Graham were friends through her work at the Aperture Foundation, and she was curious to hear more about the exhibition. A short time later she called me to say that she'd become an editor at Chronicle Books and wanted *Taking Aim* to be one of her first projects. Her great eye, intelligence, and resourcefulness helped keep the project on track. Brooke Johnson handled the design beautifully, and I am grateful to her as well as to Shona Burns and Tera Killip at Chronicle. The renowned Thomas Palmer worked with us creating duotones of the photographs for the book, to assure a beautiful end result.

At EMP, my friend and colleague Jacob McMurray has always been a great sounding board, offering sage advice based on years of experience curating exhibitions. Kate Griffin at PhotoAssist was invaluable for her detective work tracking down photographers and images. Fraenkel Gallery in San Francisco was also helpful in facilitating contacts. Kim Richter was also very helpful, putting together an impressive group of local photography collectors to offer advice, and I want to thank John and Shari Behnke, Steve Jensen, Marshal McReal, and Bill and Ruth True for their help. Of course, none of this would be possible without the generous support of the board of Experience Music Project

Finally, and most important, a deep bow of respect and admiration for the photographers whose remarkable work captures the spirit of rock 'n' roll and whose talent and generosity helped make this exhibition and book possible.

—Jasen Emmons, Curatorial Director
Experience Music Project

Image Credits

pp. 2–3 **Jim Marshall** Jimi Hendrix at sound check for the Monterey Pop Festival, Monterey Fairgrounds, Monterey, California, June 18, 1967
Copyright © Jim Marshall
Gelatin silver photograph, printed 1999
19¹⁵⁄₁₆ x 24 in. (50.6 x 60.7 cm)
Experience Music Project permanent collection

p. 8 **Mick Rock** Dude '72, Camden Town, London, England, 1972
Copyright © Mick Rock

p. 13 **Annie Leibovitz** Willie Nelson, Luck Ranch, Spicewood, Texas, 2001
Copyright © Annie Leibovitz
Gelatin silver photograph, printed 2001
23¹⁵⁄₁₆ x 20 in. (60.8 x 50.8 cm)
Experience Music Project permanent collection

pp. 14–15 **Annie Leibovitz** Emmylou Harris, Franklin, Tennessee, 2001
Copyright © Annie Leibovitz
Gelatin silver photograph, printed 2001
19¹⁵⁄₁₆ x 23¹⁵⁄₁₆ in. (50.6 x 60.8 cm)
Experience Music Project permanent collection

p. 16 **Jill Furmanovsky** Charlie Watts at the Halcyon Hotel, Holland Park, London, England, March 1991
Copyright © Jill Furmanovsky

p. 19 **Graham Nash** Johnny Cash offstage during *The Johnny Cash Show*, Nashville, Tennessee, June 1969
Copyright © Graham Nash

p. 20 **Jeff Dunas** Bo Diddley, Los Angeles, California, September 18, 1996
Copyright © Jeff Dunas

p. 21 **Dezo Hoffman** Jerry Lee Lewis, London, England, 1958
Copyright © Dezo Hoffman / REX USA.

p. 22 **Anton Corbijn** Miles Davis, Montreal, Canada, 1985
Photo Copyright © Anton Corbijn

p. 23 **Mark Seliger** Ice-T, New York, New York, 1993
Copyright © Mark Seliger

p. 25 **Anton Corbijn** John Lee Hooker's hand, Los Angeles, California, 1994
Photo Copyright © Anton Corbijn

p. 26 **Anton Corbijn** Henry Rollins, Lancaster, California, 1994
Photo Copyright © Anton Corbijn
Gelatin silver photograph
18 x 18 in. (45.7 x 45.7 cm)
Experience Music Project permanent collection

p. 27 **Anton Corbijn** Jim Kerr of Simple Minds, Los Angeles, California, 1985
Photo Copyright © Anton Corbijn

p. 28 **Jini Dellaccio** Neil Young, Laurel Canyon, Los Angeles, California, August 1967
Copyright © Jini Dellaccio. Courtesy of the Jini Dellaccio Collection

p. 29 **Neal Preston** Gregg Allman, Phoenix, Arizona, 1973
Copyright © Neal Preston/2009

p. 30 **Barron Claiborne** Notorious B.I.G., New York, New York, May 2003
Copyright © Barron Claiborne

p. 31 **Graham Nash** *Self-Portrait at the Plaza Hotel*, New York, New York, September 1974
Copyright © Graham Nash

p. 32 **Lynn Goldsmith** The Beatles, Miami Beach, Florida, February 13, 1964
Copyright © Lynn Goldsmith

p. 33 **Henry Diltz** David Crosby at the Radisson Hotel, Minneapolis, Minnesota, 1970
Copyright © Henry Diltz

p. 34 **Mick Rock** Peter Gabriel at Mick Rock's apartment, King's Cross, London, England, November 1973
Copyright © Mick Rock

p. 35 **Anton Corbijn** Frank Tovey, a.k.a. Fad Gadget, Liverpool, England, 1983
Photo Copyright © Anton Corbijn

p. 37 **Francesco Scavullo** Mick Jagger, location unknown, 1973
Copyright © Francesco Scavullo. Courtesy of The Francesco Scavullo Foundation

pp. 38–39 **Lynn Goldsmith** Marianne Faithful showering, Nassau, Bahamas, 1982
Copyright © Lynn Goldsmith

pp. 40–41 **Joel Bernstein** Neil Young, elderly woman, and Graham Nash in Greenwich Village, New York, New York, June 1970
Copyright © Joel Bernstein

p. 42 **Anton Corbijn** Joe Cocker at The Hague, The Netherlands, 1979
Photo Copyright © Anton Corbijn

p. 43 **Anton Corbijn** Nick Cave, Santa Monica, California, 1991
Photo Copyright © Anton Corbijn

p. 45 **Annie Leibovitz** Pete Seeger, Clearwater Revival, Croton-on-Hudson, New York, 2001
Copyright © Annie Leibovitz

p. 47 **Richard Avedon** Simon and Garfunkel, New York, New York, 1967
Copyright © 2009 The Richard Avedon Foundation.
Gelatin silver photograph
23¾ x 20 in. (60.3 x 50.7 cm)
Courtesy of the Fraenkel Gallery, San Francisco, California

p. 48 **Barry Feinstein** Bob Dylan's hands, Edinburgh, Scotland, 1966
Copyright © Barry Feinstein

p. 49 **Mick Rock** Freddie Mercury of Queen, London, England, 1974
Copyright © Mick Rock
Chromogenic photograph
20 x 16⅛ in. (50.8 x 40.8 cm)
Experience Music Project permanent collection

p. 50 **Richard Avedon** The Beatles: John Lennon, Paul McCartney, George Harrison, Ringo Starr, London, England, August 11, 1967
Copyright © The Richard Avedon Foundation
Four dye-transfer photographs
Each 24 x 20 in. (61 x 50.8 cm)
Courtesy of the Fraenkel Gallery, San Francisco, California

p. 52 **Joel Bernstein** Tom Petty outside Cherokee Studios during recording sessions for his 1979 album with the Heartbreakers, *Damn the Torpedoes*, Hollywood, California, March 9, 1979
Copyright © Joel Bernstein

p. 53 **Jim Marshall** Alice Cooper backstage, Denver, Colorado, 1972
Copyright © Jim Marshall
Gelatin silver photograph, printed 1999
11 x 13¹⁵⁄₁₆ in. (27.9 x 35.4 cm)
Experience Music Project permanent collection

p. 55 **Jürgen Vollmer** John Lennon in doorway as the other Beatles pass by, Hamburg, Germany, 1961
Copyright © Jürgen Vollmer/Redferns
Gelatin silver photograph
41⅝ x 29¹⁵⁄₁₆ in. (105.7 x 76 cm)
Experience Music Project permanent collection

p. 57 **Tom Wright** Rod Stewart performing during the final show by The Faces, Montreal, Canada, 1975
Copyright © Tom Wright

p. 58 **Mick Rock** Iggy Pop in performance at King's Cross Cinema, London, England, 1972
Copyright © Mick Rock

p. 59 **Barrie Wentzell** Elton John performing "Crocodile Rock" at the Sundown Theatre, Edmonton, North London, England, 1973
Copyright © Barrie Wentzell

p. 61 **Pennie Smith** Pete Townshend in performance during The Who's UK tour, 1982
Copyright © Pennie Smith

p. 62 **Bob Gruen** Sid Vicious at the Longhorn Ballroom, Dallas, Texas, January 10, 1978
Copyright © Bob Gruen

p. 63 **Elliott Landy** Levon Helm backstage at the Fillmore East, New York, New York, 1969
Copyright © Elliott Landy/LandyVision.com

pp. 64–65 **Daniel Kramer** Bob Dylan and Joan Baez in Crossed Lights, New Haven, Connecticut, March 6, 1965
Copyright © Daniel Kramer
Gelatin silver photograph
16 x 20 in. (40.6 x 50.8 cm)
Experience Music Project permanent collection

p. 66 **Lee Friedlander** Aretha Franklin, 1968
Copyright © Lee Friedlander.
Iris print on rag paper
$32^7/_{16}$ x $32^3/_4$ in. (82.4 x 83.2 cm)
Experience Music Project permanent collection.
Courtesy of the artist and the Fraenkel Gallery, San Francisco, California

p. 67 **Elliott Landy** Janis Joplin in performance at the opening of the Fillmore East, New York, New York, March 8, 1968
Copyright © Elliott Landy/LandyVision.com

p. 69 **Annie Leibovitz** B.B. King, Club Ebony, Indianola, Mississippi, 2000
Copyright © Annie Leibovitz
Gelatin silver photograph, printed 2001
$19^{15}/_{16}$ x $32^{15}/_{16}$ in. (50.6 x 60.8 cm)
Experience Music Project permanent collection

p. 70 **Lynn Goldsmith** Eddie Van Halen in performance, Los Angeles, California, 1979
Copyright © Lynn Goldsmith

p. 71 **Neal Preston** Prince in performance, Detroit, Michigan, 1984
Copyright © Neal Preston/2009

pp. 72–73 **Lynn Goldsmith** Keith Richards, Neil Young, and Chuck Berry perform at the first Rock and Roll Hall of Fame induction ceremony, New York, New York, January 23, 1986
Copyright © Lynn Goldsmith

p. 75 **David Redfern** Bill Haley & His Comets in performance on *Thank Your Lucky Stars*, Aston Studios, Birmingham, England, 1964
Copyright © David Redfern

pp. 76–77 **Charles Peterson** Crowd with body surfers during Mudhoney's set at the KNDD Endfest, Kitsap County, Washington, 1991
Copyright © Charles Peterson
Gelatin silver photograph
$15^{15}/_{16}$ x $19^{13}/_{16}$ in. (40.5 x 50.4 cm)
Experience Music Project permanent collection

p. 79 **Roger Marshutz** Elvis Presley in performance at the Mississippi-Alabama State Fair and Dairy Show, Tupelo, Mississippi, September 28, 1956
Copyright © Roger Marshutz Estate

pp. 80–81 **Barry Feinstein** Bob Dylan signing a poster at the Olympia Concert Hall, Paris, France, 1966
Copyright © Barry Feinstein

p. 82 **Alan Messer** Marc Bolan of T. Rex at the Sundown Theatre, Edmonton, North London, England, December 1972
Copyright © Dezo Hoffmann Collection— Rex Features

p. 85 **Charles Peterson** Krist Novoselic, Kurt Cobain, and Chad Channing of Nirvana in performance at Raji's, Hollywood, California, February 15, 1990
Copyright © Charles Peterson
Gelatin silver photograph
$19^7/_8$ x 16 in. (50.4 x 40.6 cm)
Experience Music Project permanent collection

p. 86 **Harry Hammond** Eddie Cochran in performance, Wembley, London, England, 1960
Copyright © Harry Hammond/V&A Images, V&A Theatre Collections

p. 87 **Ed Sirrs** Ned's Atomic Dustbin in performance at Kilburn National, London, England, 1991
Copyright © Ed Sirrs

p. 88 **Ernest Withers** Ray Charles and Hank Crawford in performance at City Auditorium, Memphis, Tennessee, circa 1961
Copyright © Ernest C. Withers Estate. Courtesy Panopticon Gallery, Boston, MA

p. 89 **Jim Marshall** Peter Yarrow, Mary Travers, Noel "Paul" Stookey, Joan Baez, Bob Dylan, The Freedom Singers, Peter Seeger, and Theodore Bikel perform "We Shall Overcome" at the Newport Folk Festival, Newport, Rhode Island, July 28, 1963
Copyright © Jim Marshall
Gelatin silver photograph, printed 2009
$16^1/_{16}$ x $19^{15}/_{16}$ in. (40.7 x 50.6 cm)
Courtesy of an anonymous collector

p. 90–91 **Jim Marshall** The Beatles—John Lennon, George Harrison, Paul McCartney, and Ringo Starr—walking to the stage at Candlestick Park, San Francisco, California, August 29, 1966
Copyright © Jim Marshall
Gelatin silver photograph, printed 1999
$19^{15}/_{16}$ x 24 in. (50.6 x 60.9 cm)
Experience Music Project permanent collection

p. 92 **Henry Diltz** The Mamas & the Papas—Cass Elliot, Michelle Phillips, Denny Doherty and John Phillips— backstage at the Hollywood Bowl, Los Angeles, California, 1967
Copyright © Henry Diltz

p. 93 **Robertson & Fresh Photo Company** Elvis Presley in performance, Tampa, Florida, July 31, 1955
Copyright © Elvis Presley Estate

p. 95 **David Redfern** Gene Vincent in performance, Calais Harbor, France, 1959
Copyright © David Redfern

p. 96 **Bob Gruen** Tina Turner in performance at the Honkamonka Room, Queens, New York, July 1970
Copyright © Bob Gruen

p. 97 **Lynn Goldsmith** Paul Stanley of KISS in performance, Madison Square Garden, New York, New York, July 1979
Copyright © Lynn Goldsmith

p. 98 **Charles Peterson** Fugazi in performance at the International Pop Underground Festival, Capitol Theater, Olympia, Washington, 1991
Copyright © Charles Peterson
Gelatin silver photograph
$19^7/_8$ x 16 in. (50.5 x 40.6 cm)
Experience Music Project permanent collection

p. 99 **Graham Nash** Taj Mahal in performance at the Mariposa Folk Festival, Centre Island, Toronto, Canada, 1970
Copyright © Graham Nash

p. 100 **Neal Preston** Robert Plant in performance during Led Zeppelin's North American tour, location unknown, 1975
Copyright © Neal Preston/2009

p. 101 **Neal Preston** Jimmy Page in performance during Led Zeppelin's North American tour, Oklahoma City, Oklahoma, 1977
Copyright © Neal Preston/2009

pp. 102–103 **Joel Bernstein** David Crosby, Stephen Stills, and Graham Nash recording their album, CSN, at Criteria Studio, Miami, Florida, March 1977
Copyright © Joel Bernstein

p. 105 **Jim Marshall** Bob Dylan waiting to perform at the Newport Folk Festival, Newport, Rhode Island, July 1963
Copyright © Jim Marshall
Gelatin silver photograph, printed 2009
14 x 11 in. (35.5 x 27.9 cm)
Courtesy of an anonymous collector

p. 106 **Lynn Goldsmith** David Bowie performing at Radio City Music Hall, New York, New York, February 1973
Copyright © Lynn Goldsmith

p. 107 **Lynn Goldsmith** Mick Jagger warming up backstage at the Community Center, Tucson, Arizona, July 21, 1978
Copyright © Lynn Goldsmith

pp. 108–109 **Bob Gruen** The Clash in performance at Harvard Square Theatre, Cambridge, Massachusetts, February 16, 1979
Copyright © Bob Gruen

p. 111 **Chris Walter** Bruce Springsteen and Clarence Clemons in performance at the Los Angeles Sports Arena, Los Angeles, California, August 20, 1981
Copyright © Chris Walter

pp. 112–113 **Jim Marshall** Johnny Cash flipping the bird at San Quentin Prison, San Quentin, California, 1969
Copyright © Jim Marshall
Gelatin silver photograph, printed 2009
16 x 19¹⁵⁄₁₆ in. (40.6 x 50.6 cm)
Courtesy of Brian Marsh and Michelle Dunn Marsh

p. 115 **Alfred Wertheimer** Elvis Presley eating breakfast at the Jefferson Hotel, Richmond, Virginia, June 30, 1956
Copyright © Alfred Wertheimer

pp. 116–117 **Joel Bernstein** Bob Dylan with his tour crew, Hong Kong International Airport, Hong Kong, March 1978
Copyright © Joel Bernstein

p. 119 **Henry Diltz** Cass Elliot of the Mamas & the Papas, Los Angeles, California, 1968
Copyright © Henry Diltz.

p. 120 **Alice Wheeler** *Neko Case and Her Boyfriends*, Tacoma, Washington, February 2000
Copyright © Alice Wheeler

p. 121 **Lynn Goldsmith** Sting on a motorcycle with the photographer, Los Angeles, California, 1981
Copyright © Lynn Goldsmith

pp. 122–123 **Henry Diltz** Graham Nash, Stephen Stills, and David Crosby on abandoned couch, Los Angeles, California, February 1969
Copyright © Henry Diltz

p. 124 **Anton Corbijn** Elvis Costello at his hotel during the *My Aim Is True* tour, Amsterdam, The Netherlands, 1977
Copyright © Anton Corbijn
Gelatin silver photograph
36¼ x 53½ in. (92 x 135.8 cm)
Experience Music Project permanent collection

p. 125 **Annie Leibovitz** Chris Stein and Debbie Harry of Blondie, Indianapolis, Indiana, 1979
Copyright © Annie Leibovitz

p. 126 **Jim Marshall** Janis Joplin sitting on a couch backstage at Winterland, San Francisco, California, 1968
Copyright © Jim Marshall
Gelatin silver photograph, printed 1999
19¹⁵⁄₁₆ x 16 in. (50.6 x 40.6 cm)
Experience Music Project permanent collection

pp. 128–129 **Graham Nash** Joni Mitchell listening to music, Laurel Canyon, Los Angeles, California, 1969
Copyright © Graham Nash

p. 131 **Annie Leibovitz** Yoko Ono and John Lennon, New York, New York, December 8, 1980
Copyright © Annie Leibovitz

pp. 132–33 **Joel Bernstein** Jackson Browne at sound check, Pine Knob Amphitheatre, Clarkson, Michigan, August 22, 1977
Copyright © Joel Bernstein

pp. 134–135 **Jim Marshall** Bob Dylan kicking tire, New York, New York, 1963
Copyright © Jim Marshall
Gelatin silver photograph, printed 1999
11¹⁄₁₆ x 14 in. (28.1 x 35.6 cm)
Experience Music Project permanent collection

pp. 136–137 **Henry Diltz** The Doors—Ray Manzarek, Jim Morrison, Robbie Krieger and John Densmore—at the original Hard Rock Café, Los Angeles, California, December 1969
Copyright © Henry Diltz

p. 138–139 **Annie Leibovitz** Brian Wilson, Bel-Air, California, 1970
Copyright © Annie Leibovitz

pp. 140–141 **Dennis Hopper** Ike and Tina Turner during a photo session for *River Deep, Mountain High*, Los Angeles, California, 1965
Gelatin silver photograph
16 x 24 in. (40.6 x 61 cm)
Copyright © Dennis Hopper. Courtesy of the artist and Craig Krull Gallery, Santa Monica, California

p. 143 **Dennis Morris** Bob Marley, location unknown, 1975
Copyright © Dennis Morris

p. 144 **Annie Leibovitz** Jerry Garcia at the Navarro Hotel, New York, New York, 1973
Copyright © Annie Leibovitz
Gelatin silver photograph
16 x 19⁷⁄₈ in. (40.6 x 50.4 cm)
Experience Music Project permanent collection

p. 145 **Joel Bernstein** Neil Young at home near Woodside, California, September 1971
Copyright © Joel Bernstein

p. 147 **Lew Allen** Buddy Holly on a tour bus with drummer Jerry Allison and singer Judith Shepherd seated in front of him and Frank Maffei of Danny and the Juniors standing in the aisle, Rochester, New York, circa 1958
Copyright © Lew Allen

pp. 148–149 **Jim Marshall** June Carter Cash and Johnny Cash listening to music, Hendersonville, Tennessee, 1969
Copyright © Jim Marshall
Gelatin silver photograph, printed 1999
16 x 20¹⁵⁄₁₆ in. (40.6 x 50.6 cm)
Experience Music Project permanent collection

pp. 150–151 **Graham Nash** Neil Young driving home to Broken Arrow Ranch after a performance by Crosby, Stills, Nash & Young, Northern California, 1988
Copyright © Graham Nash

ILLUSTRATIONS

p. 153 **Walter Sanders** Audience members enjoy Alan Freed's rock 'n' roll show at the Paramount Theater, Brooklyn, New York, January 1, 1955
Copyright © Walter Sanders/Time Life Pictures/Getty Images

p. 153 **Photographer unknown** The Million Dollar Quartet—Jerry Lee Lewis, Carl Perkins, Elvis Presley, and Johnny Cash—in Sun Studios, Memphis, Tennessee, December 4, 1956
Copyright © Michael Ochs Archives/Corbis

p. 155 **Joel Bernstein** Neil Young and his wife, Susan Acevedo, backstage at the Electric Factory before a performance with Crazy Horse, Philadelphia, Pennsylvania, February 28, 1970
Copyright © Joel Bernstein

159

Index

A

Acevedo, Susan, 154, 155
Adams, Ansel, 9
Allen, Lew, 147
Allison, Jerry, 147
Allman, Gregg, 29
Arbus, Diane, 10
Avedon, Richard, 47, 51, 154

B

Baez, Joan, 64–65, 89, 154
The Band, 154
The Beatles, 21, 32, 50–51, 54–55, 90–91, 154
Bernstein, Joel, 40–41, 52, 103, 117, 132, 145, 154, 155
Berry, Chuck, 72–73
The Big Bopper, 146, 155
Bikel, Theodore, 89
Bill Haley & His Comets, 74–75
Body Count, 23
Bolan, Marc, 82–83
Bowie, David, 106
Browne, Jackson, 132–33
The Byrds, 104

C

Carter, June, 148–49
Case, Neko, 120
Cash, Johnny, 18–19, 112–13, 149, 153
Cave, Nick, 43
Cerami, Calli, 31
Channing, Chad, 84–85
Claiborne, Barron, 40
The Clash, 108–9, 155
Clemons, Clarence, 110–11
Cobain, Kurt, 84–85, 155
Cochran, Eddie, 86
Cocker, Joe, 42
Cooper, Alice, 53
Corbijn, Anton, 22, 25–27, 35, 42, 43, 124
Costello, Elvis, 124
Crazy Horse, 155
Crosby, David, 33, 102–3, 104, 118, 123
Crosby, Stills, & Nash, 33, 102–3, 118, 122–23
Crosby, Stills, Nash, & Young, 31, 151
Curtis, Edward, 10

D

Davis, Miles, 22
Dellaccio, Jini, 28
Densmore, John, 137
Diddley, Bo, 20
Diltz, Henry, 33, 92, 118, 123, 137
Doherty, Denny, 92
The Doors, 136–37
Dunas, Jeff, 20
Dylan, Bob, 48, 64, 80–81, 89, 104–5, 116–17, 134–35, 154

E

Elliot, Cass, 92, 118–19
Epstein, Brian, 154

F

The Faces, 57, 155
Fad Gadget, 35
Faithful, Marianne, 38–39
Feinstein, Barry, 48, 80, 154
Franklin, Aretha, 66
Freed, Alan, 153
The Freedom Singers, 89
Friedlander, Lee, 66
Fugazi, 98
Furmanovsky, Jill, 16

G

Gabriel, Peter, 34
Garcia, Jerry, 144
Goldsmith, Lynn, 32, 38, 70, 72, 97, 106, 107, 121, 155
Grohl, Dave, 155
Gruen, Bob, 62, 96, 109
Guthrie, Woody, 44, 154

H

Haley, Bill, 74–75
Hammond, Harry, 86
Harris, Emmylou, 15
Harrison, George, 50–51, 90, 154
Harry, Debbie, 125
The Hawks, 154
The Heartbreakers, 52
Helm, Levon, 63, 154
Hendrix, Jimi, 2–3, 4, 153–54
Hoffman, Dezo, 21
The Hollies, 21, 146
Holly, Buddy, 146–47, 155
Hooker, John Lee, 25
Hopper, Dennis, 140

I

Ice-T, 23

J

Jagger, Mick, 36–37, 107, 155
John, Elton, 59
Joplin, Janis, 67, 126–27, 155

K

Kerr, Jim, 27
King, B.B., 68–69
KISS, 97
Kramer, Daniel, 64, 154
Krieger, Robbie, 137

L

Landy, Elliott, 63, 67, 154
Led Zeppelin, 100, 101
Leibovitz, Annie, 13, 15, 45, 69, 125, 130, 139, 144
Lennon, John, 50–51, 54–55, 90, 130–31, 154
Lewis, Jerry Lee, 21, 153

M

Mahal, Taj, 99
The Mammas and the Papas, 92
Manzarek, Ray, 136–37
Marley, Bob, 142–43
Marshall, Jim, 4, 53, 89, 90, 105, 112–13, 127, 134, 149, 153–54
Marshutz, Roger, 79
McCartney, Paul, 50–51, 90–91, 154
Mercury, Freddie, 49
Messer, Alan, 83
Mitchell, Joni, 18, 128–29
Morris, Dennis, 142
Morrison, Jim, 136–37
Mudhoney, 77

N

Nash, Graham, 9–11, 19, 40–41, 99, 103, 118, 123, 128, 146, 151
Ned's Atomic Dustbin, 87
Neko Case and Her Boyfriends, 120
Nelson, Willie, 13
Nirvana, 84–85
Notorious B.I.G., 40
Novoselic, Krist, 84–85

O

Ono, Yoko, 130–31

P

Page, Jimmy, 101
Perkins, Carl, 153
Peterson, Charles, 77, 84, 98
Petty, Tom, 52
Phillips, John, 92
Phillips, Michelle, 92
Plant, Robert, 100, 155
Pop, Iggy, 58
The Presidents of the United States, 152–53
Presley, Elvis, 79, 93, 115, 153
Preston, Neal, 29, 71, 100, 101
Prince, 71

Q

Queen, 49

R

Redfern, David, 75, 95
Richards, Keith, 72
Rock, Mick, 8, 34, 49, 58
Rollins, Henry, 26

S

Scavullo, Francesco, 36
Seeger, Pete, 44–45, 89
Seliger, Mark, 23
Shepard, Judith, 147
Simon and Garfunkel, 47
Simple Minds, 27
Sirrs, Ed, 87
Smith, Pennie, 60
Springsteen, Bruce, 110–11
Stanley, Paul, 97
Starr, Ringo, 50–51, 90–91
Stein, Chris, 125
Stewart, Rod, 57, 155
Stills, Stephen, 102–3, 118, 123
Sting, 121
Stookey, Noel "Paul," 89
Sutcliffe, Stu, 154

T

T. Rex, 83
Tovey, Frank, 35
Townshend, Pete, 60–61, 155
Travers, Mary, 89
Turner, Ike, 140
Turner, Tina, 96, 140–41, 155

V

Valens, Ritchie, 146, 155
Van Halen, Eddie, 70
Vicious, Sid, 62
Vincent, Gene, 94–95
Vollmer, Jürgen, 54, 154

W

Walter, Chris, 110
Watts, Charlie, 16
Wentzell, Barrie, 59
Wertheimer, Alfred, 115
Wheeler, Alice, 120
The Who, 60
Wilson, Brian, 139
Wright, Tom, 57

Z

Yarrow, Peter, 89
Young, Neil, 28, 40–41, 72, 118, 145, 150–51, 154, 155